LOST
LEXINGTON
K E N T U C K Y

PETER BRACKNEY

FOREWORD BY
MAYOR JIM GRAY

THE
History
PRESS

Published by The History Press
Charleston, SC 29403
www.historypress.net

Front cover: Author's Collection. *Back cover*: Courtesy of the University of Kentucky Libraries.

First published 2014

Manufactured in the United States

ISBN 978.1.62619.599.8

Library of Congress CIP data applied for.

This book is dedicated to my parents, who fostered my love for history, and to my wife, who must endure it.

CONTENTS

FOREWORD

In the nearly two and a half centuries since Lexington was founded in 1775, this once-frontier settlement has grown into a flourishing city of more than 300,000 residents. It has produced some remarkable landmarks and people. These entrepreneurs, intellectuals and civic leaders had the imagination and vision that helped make Lexington what it is today: a city that embraces new ideas and innovation while valuing its rural landscape and authentic past.

The story of how Lexington has evolved to its present-day landscape is a story of balancing preservation and progress. Philosophies, priorities and ideas change—for better or for worse. And of course, Lexington's architecture and landscape have reflected those changes.

In *Lost Lexington*, Peter Brackney highlights several sites that, for a variety of reasons, did not survive as the city grew. Brackney's work explores structures that were lost over a century ago, as well as more modern buildings and attractions, of which many readers will have personal memories and recollections.

Reflecting on Lexington's architectural journey is a meaningful exercise. Drawing upon Brackney's fascinating research, we can see these stories as important lessons for the way forward. As Lexington continues to reinvent itself, it is the city's unique and rich past that will inform and inspire its future.

JIM GRAY
Mayor of Lexington

PREFACE

Though not a native Kentuckian, I have called central Kentucky home since I was in the first grade. I grew up in a fine old house in downtown Lexington's Historic Western Suburb; while living here, I discovered my passion for history.

The most recent section of my childhood home was built by John McMurtry in 1843. It is full of personal memories for me, but the house also played a larger role in a bigger world. Erected in stages, the house reached to the early annals of the Western Suburb's existence. The neighborhood was Lexington's first, and it witnessed some of the city's most interesting events and most notorious characters. The City of Lexington, once the Athens of the West, was instrumental in our nation's westward expansion.

Despite the strong, and quite literal, foundation in history, I never pursued the liberal arts during college, yet my passion for history never waned. Still, my early upbringing in a Civil War–themed room and my love of history-related family trips found me embracing history. To paraphrase the great Kentucky journalist Al Smith, "History is in the genes." And I have that "history gene."

In learning about Kentucky's past, whether its people, places or events, I have discovered so many threads that weave through our Commonwealth's history. It never ceases to amaze me how those common threads reemerge as I'm researching a different subject in Kentucky's history. A common place or a shared ancestor or business partner will link stories when least expected. This is certainly the case in *Lost Lexington*, where characters and places in one

chapter reemerge in another. Some of these links are immediately apparent, while others are subtler.

Whether you attribute the old quote to an old Baptist preacher or to Daniel Boone himself does not matter, for the maxim is still true: "Heaven must be a Kentucky of a place." People often wonder what heaven will be like. We often ask with whom we'd like to engage once we arrive at the Pearly Gates. Whether an old friend or a fascinating individual from the past, we want to learn more about their lives, their families and the places they've been. So it is with studying Kentucky's past.

And these interwoven stories of Kentucky's history are truly heavenly. Yes, I believe it is so: "Heaven must be a Kentucky of a place." But we are losing part of that heaven as buildings are demolished and green space is lost. And while the structures described in this book may be gone, these connections should not be forgotten. This book serves as a reminder of what once was.

ACKNOWLEDGEMENTS

There are so many people who played a role in this book. But first, I must give my thanks to the love of my life, Morganne, and to our children, who offered me so many hours (both uninterrupted and interrupted) of time to write.

Then there are all of those who directly assisted with the research, the writing or the editing. I've bounced ideas off of you and learned that several of my ideas had no bounce. To each, I say thank you!

In the time-honored tradition of alphabetical order, my thanks go out to Rachel Alexander, Bill Ambrose, Peter Bourne, Becky Eblen, Yvonne Giles, Nate Kissel, Kirsten Minnie, Marty Perry, Jason Sloan and Debra Watkins. Each tremendously helped in some way with the preparation of this text.

Many thanks to the organizations that have provided materials for research, for the use of images and for being committed to preserving and sharing our history. Specifically, those at the Blue Grass Trust for Historic Preservation, LexHistory (formerly the Lexington History Museum), the Kentucky Heritage Council and the University of Kentucky. To each involved, thank you!

And to my hometown of Lexington: you are awesome! I love this community from the downtown core to the inner ring neighborhoods to the bedroom communities outside of Fayette County. All of this is a part of Lexington, a vibrant and living community for almost 240 years!

INTRODUCTION

An architect whose work features prominently in Lexington once said, "architecture has been called the art of building beautifully, a fixation of man's thinking, and record of his activity." But what happens when that record is lost?

Architecture, through buildings, can provide us with tangible reminders of people, places and events. Buildings themselves can trigger memories. Each building has a story that contributes to our human history. Though many find history and its preservation to be an unnecessary exercise, I would suggest that we must understand and preserve our history in order to better understand ourselves. *Lost Lexington* merely cracks the surface of what has been lost to history. Each loss has been prompted by a different cause. Whether a government policy, a private development, an arsonist's hand, pure spite or an act of God, Lexington has been and will continue to be changed from what was, what is and what is to come. *Lost Lexington* reminds us of what once was and aims to encourage our future selves to remember from whence we came. Woven together, these buildings are part of the record of our activities and tell our stories.

HART-BRADFORD HOUSE

The simple three-bay home at the southwest corner of Mill and Short Streets was nothing grand to behold. A plain belt course appeared to have been its most unique architectural attribute. The grandeur of the Hart-Bradford House, though, could be found in both its location and in the spirit of those who once lived within its walls.

Across Second Street, the storied Hunt-Morgan House was erected by John Wesley Hunt. Hunt was the first millionaire this side of the Allegheny Mountains. The Hunt-Morgan House also counted Henrietta Hunt Morgan among its residents; she was the mother of General John Hunt Morgan—the infamous guerrilla raider nicknamed the Thunderbolt of the Confederacy. It is also the birthplace of the "father of modern genetics," Dr. Thomas Hunt Morgan. Together, the Hart-Bradford and Hunt-Morgan homes bound Gratz Park at its southwest corner. In the words of the late Clay Lancaster, Gratz Park is a downtown haven that "has charm, atmosphere, a sense of tranquility and of history, and it provides an oasis of planting tucked into the cityscape."

A full book could be written on the structures that stand (or once stood) in and around Gratz Park. Most notably, the primary structure of what is now Transylvania University once stood in the center of the park. Designed by architect Matthew Kennedy, the three-story academic building was constructed in 1816 but burnt to the ground in 1829. After the fire, Transylvania retreated to the north side of Third Street.

Watching history unfold at the far southwestern end of the oasis was 193 North Mill Street—arguably one of Lexington's most historic structures.

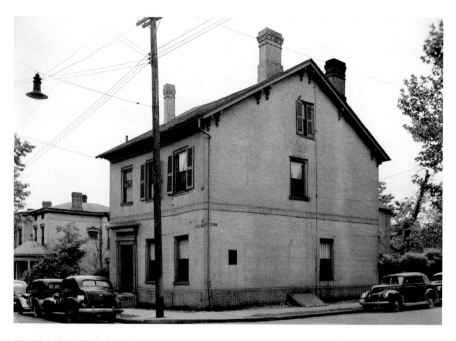

The Bradford House, seen here circa 1940, was demolished in 1955. *Courtesy of the Historic American Buildings Survey (Library of Congress).*

Within the walls of the venerable structure, a series of influential citizens resided. Another group of citizens rose up after her demise, in what became the true beginning of central Kentucky's historic preservation movement.

COLONEL THOMAS HART

The first of the legendary occupants of 193 North Mill Street was Colonel Thomas Hart. Colonel Hart had the home constructed in 1798, after only four years in Kentucky. Though sixty-three years old at the time he arrived in Kentucky, his influence had already permeated the Commonwealth.

Colonel Hart was born in 1730 in Hanover County, Virginia. After the death of his father in 1755, he and his family relocated to North Carolina. Through a variety of enterprises, Hart acquired significant wealth and land holdings there.

Colonel Hart turned his eye toward Miss Susanna Gray, who was some eighteen years his junior. It is often repeated that Miss Gray's father, Colonel

John Gray, was vehemently opposed to the courtship and union of the two, on grounds that Hart was a rebel. This suggestion, however, seems baseless. Though he was a patriot in the American Revolution, these events could not have affected Colonel Gray's opinion of Hart.

Grounds for the assertion that Hart was disloyal to the Crown include his membership in two provincial congresses of North Carolina and his status as a colonel in the Revolutionary War. But North Carolina's first provincial congress commenced in August 1774, and Hart's appointment to the rank of colonel occurred on April 23, 1776. He served for approximately four months as a commissary for the Sixth North Carolina Regiment. Each of these events occurred long after the 1764 nuptials between Susanna Gray and Thomas Hart.

At the time of their vows, Thomas Hart served as the sheriff for Orange County, North Carolina. His post was held during the War of Regulation, a local conflict in North Carolina against both the provincial governor and an unpopular poll tax, which the sheriff was responsible for collecting. Largely, Hart represented the government interests in opposition to the Regulators. This, too, would not seem a basis for his father-in-law's alleged opinion of Hart as an "ardent rebel." Perhaps Colonel John Gray simply was not prepared for his only daughter to be married off. Regardless, whatever animosity may have ever existed between the two men dissipated. At the end of Colonel Gray's life, he left his entire estate to Thomas Hart.

In August 1774, Thomas Hart helped to establish the Louisa Company. The company was organized to obtain titles to lands in what is today known as Kentucky and Tennessee. Soon after, Hart traveled as part of this enterprise to the Watauga River valley to meet with members of the Cherokee Nation and exchange gifts. The Louisa Company was re-chartered as the Transylvania Company the following January. In March 1775, members of the Transylvania Company and leaders of the Cherokee Nation entered into the Treaty of Sycamore Shoals, by which the natives ceded a sizable portion of present-day Tennessee and Kentucky to the enterprise.

The following year, attempts were made to have this Transylvania territory admitted as the fourteenth state of the Union, but the Continental Congress never adopted this. Ultimately, neither Virginia nor North Carolina would acknowledge the claims of the Transylvania Company, and the acquisition was found to be illegal. Hart and the other investors were paid for their expenses, and Hart accepted land in what became known as Virginia's Kentucky District.

As the Revolutionary War continued, Thomas Hart's increased allegiance to the Patriots' cause became a danger to both Hart and his family. For this

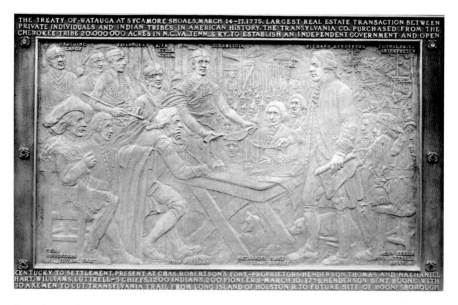

Seated second from the left is Thomas Hart (1730–1808). The plaque, located on the courthouse in Henderson, Kentucky, portrays the signing of the Treaty of Watauga at Sycamore Shoals in 1775. *Courtesy of the University of Kentucky Libraries.*

reason, the family moved to Maryland in November 1780. At the time of their emigration from North Carolina to Maryland, Thomas Hart was the wealthiest man in the county. Hart's North Carolina holdings were sold to Jesse Benton. The two were also friends, and Benton named his son after Hart. As a United States senator from Missouri, Thomas Hart Benton would become a leading proponent for Manifest Destiny and America's westward expansion. Hart's departure to Maryland occurred at an opportune time because, in only a few months, a portion of the land left behind would become the site of the Battle of Hart's Mill, in February 1781.

Some fourteen years after departing North Carolina for Hagerstown, Maryland, Colonel Thomas Hart sent a letter to friends in Lexington, Kentucky. In it, he requested that they would "procure me a House in Lexington for the reception of my family in the Spring." Colonel Hart had long wanted to return to the lands he had explored years before as part of the Louisa and Transylvania companies. To his friend, Governor William Blount of the Southwest Territory (which would later become Tennessee), Hart wrote:

> *You will be surprised to hear I am going to Kentucky. Mrs. Hart, who for eighteen years has opposed this measure, has now given her consent and so*

we go, an old fellow of 63 years of age seeking a new country to make a fortune in…

Susanna Hart was undoubtedly a strong woman. Thirty years earlier, she had defied her father's wishes by marrying Hart. And for eighteen years, she had persuaded her groom to not lay roots in Kentucky. Now having his wife's consent, Colonel Hart took advantage of the opportunity. By early June 1794, the family would arrive in Lexington.

In advance of his arrival, Colonel Hart caused the following to be published in the February 18, 1794 edition of the *Kentucky Gazette*:

The Subscribers, intending to remove to Kentucky in Spring and wishing to see manufacturers (as well as trade and commerce) flourish in that country, have purchased and are now sending off a number of French Burr Millstones, which they will take down the river with them, together with superfine Bolting Cloths, &c. They propose also to establish a nail manufactory on so large a scale as to supply the whole of Kentucky with nails of every kind. They will also establish a Tin Manufactory and a Rope Manufactory in said town and supply the inhabitants on lower terms with their manufactures than these articles have hitherto been furnished. THOMAS HART & SON.

The entire block bound by today's Broadway, Second, Mill and Church Streets would be acquired by Thomas Hart within a short time of his arrival in Lexington, and the block would be quite useful in his many successful ventures.

One of the most significant events to occur at 193 North Mill was on April 11, 1799. In the home's parlor, twenty-one-year-old Henry Clay married Lucretia Hart, eighteen. As a wedding gift, Thomas Hart gave his daughter and new son-in-law the neighboring house to call their own. Within a few years, the young couple would amass sufficient wealth to acquire their own land outside town, where Clay would build his Ashland estate. At the time, however, Clay practiced law across Mill Street in a building that remains standing today.

Thomas Hart died on June 23, 1808. His last will and testament was probated in the Fayette County Court. In it, he gave to his "wife during her life the house and lot which I at present occupy in Lexington, also during the same period all my household and kitchen furniture and one hundred fifty pounds annually."

The house then occupied by Hart and given to his wife, however, wasn't our Hart-Bradford House. Their son, Thomas Hart Jr., had acquired the deed to the property in 1802. Subsequently, Hart Jr. sold the residence to John Bradford on March 20, 1806, for $5,000.

John Bradford

Like Hart, John Bradford was a native Virginian. Born in 1749 in Fauquier County, Virginia, Bradford immigrated to Kentucky in 1779. Tom Eblen of the *Lexington Herald-Leader* described Bradford as "a Renaissance man of the early Western frontier" before creating a laundry list of endeavors in which Bradford found himself actively occupied: "land surveyor, Indian fighter, politician, moral philosopher, tavern owner, sheriff, civic host, community booster, postal service entrepreneur, real estate speculator, subdivision developer, mechanic and mathematician."

It was, however, Bradford's publication of the *Kentucke Gazette* that brought him the most acclaim. When publication began on August 11, 1787, the *Kentucke Gazette* was the first newspaper in the Commonwealth. The first issue was printed in the back room of the courthouse, which was then located at the northwest corner of Main and Broadway Streets. The city of Lexington, in exchange for Bradford's agreement to publish the newspaper there, promised a free shop for the press.

No copies of the first issue of the *Kentucke Gazette* still exist, though the Lexington Public Library does hold the largest *Gazette* collection, with its oldest issue dated August 18, 1787. That was the then-weekly paper's second edition.

In addition to being Kentucky's first newspaper, the publication was also Bradford's first attempt at newspaper publication. The endeavor began with Fielding Bradford, John's brother. The press itself was a second-hand press purchased in Philadelphia, Pennsylvania, while much of the typeface was acquired in Pittsburgh, Pennsylvania. Initially, John Bradford's *Gazette* had 180 subscribers, for which he accepted payment either at a rate of eighteen shillings per year or the same value in "corn, wheat, country-made linen, sugar, whiskey, ash flooring, and cured bacon." Over time, the regularity with which the *Gazette* would be published increased to three times per week.

Regularity of publication, however, did not equate to financial success. In the issue of the *Kentucke Gazette* dated November 7, 1789, John Bradford printed the following notice indicating the paper's financial condition:

I am in such EXTREME want of READY MONEY, that I will discount 20 per cent. on [sic] every account due to this office...I therefore hope that those who are indebted, will use their utmost endeavours to settle and pay up their respective balances by that date.—Produce is no longer receivable in discharge of debts due this office. JOHN BRADFORD.

Fortunately for the early Kentucky newspaper, an act by the Virginia legislature a few months earlier also helped stabilize revenues. The act required the insertion of certain legal advertisements in the *Kentucke Gazette*. This legislative fiat also had a significant change on the western newspaper by prompting it to alter the spelling of its masthead: from the *Kentucke Gazette* to what we now view as the conventional spelling of Kentucky. The first issue of the alternatively spelled *Kentucky Gazette* was published on March 14, 1789.

When Kentucky achieved statehood in 1792, the new government also awarded a contract for all legally required public notices to the *Kentucky Gazette*. Bradford's *Gazette* was awarded this contract every year through 1798, except 1796.

Those who have reviewed the existing issues of Bradford's paper have uniformly commented on its minimal coverage of local events. Because the *Kentucky Gazette* began as the only newspaper within five hundred miles of Lexington, Bradford must have found it critical to focus his words on covering events of regional and national import. In his 1872 *History of Lexington Kentucky*, George W. Ranck described the coverage of the "locals" in the *Kentucky Gazette* as being "vexatiously scarce [sic]."

When Bradford turned his press toward covering local events, it most often was at the expense of Native Americans. Although both natives and settlers initiated hostilities, Bradford focused exclusively on the heinous acts committed by the Indians. This prejudiced coverage of the news represented the viewpoints of only editor and reader, though the modern consumer of news might recognize this one-sided format even today. Among other things, Bradford's writings on Indian affairs and the settlement of Kentucky evinced his commitment to the American ideal, to the nation's expansion and to the notion of Manifest Destiny, a concept that suggested Providence would lead America to expand her borders and to reshape the world in her image.

By the time Bradford acquired the Hart residence at 193 North Mill Street, he had already given up editorial duties at the *Kentucky Gazette*. On

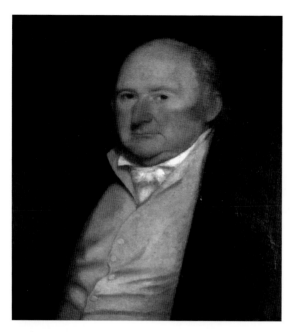

John Bradford (1749–1830) was a prominent Lexingtonian and the first publisher of the *Kentucky Gazette*. His portrait hangs in the Bodley-Bullock House in Lexington. *Courtesy of the Lexington Junior League.*

April 1, 1802, Bradford transferred the paper to his son, Daniel. Daniel sold the newspaper in 1809 to Thomas Smith. Fielding Bradford Jr., the nephew of John Bradford and son of Bradford's original co-publisher, later purchased the *Kentucky Gazette* from Smith in 1814.

In May 1825, Bradford returned as editor of the newspaper he had begun. During this reprisal, Bradford published a series of sixty-six articles entitled "Notes on Kentucky" in the paper. These notes set forth Kentucky's early history with a heavy tilt toward the ideals of Manifest Destiny that Bradford had espoused in his earlier publications. In June 1827, Bradford left the printing press for good.

Although his activities as a printer and editor made Bradford one of Lexington's most significant men, his contributions to the region go far beyond his occupation. Bradford was also often the man behind the scenes accomplishing much and bringing Lexington forward with him. It is a valid question to ask whether Lexington could have become the Athens of the West if it had not been for Bradford.

In political life, Bradford twice represented the community in the state legislature. He also served as the sheriff of Fayette County. As Lexington was not incorporated by the state legislature until 1846, its earliest form of government was a board of trustees. For a time, Bradford served as chairman of the Trustees of Lexington.

In service to literacy, Bradford was a shareholder in the Transylvania Library Company. The company "proposed the formation of a library for the benefit of the students of Transylvania Seminary—who has no sufficient

library of their own—and for future pleasure and instructions of the citizens of Lexington." With one hundred shares of stock in the company purchased, an order was placed to Philadelphia for 307 books at a cost of about $500. Over time, the library would grow its offerings, and it would be the forebearer to the Lexington Public Library.

On March 22, 1830, Bradford died at his home on the corner of Second and Mill Streets. His burial location is unknown, but there is some evidence from the early twentieth century that the location was under what is now the western wall of the First Baptist Church on Main Street. That location was the site of Lexington's first burial grounds.

In 1926, the John Bradford Society dedicated and mounted a plaque on the Second Street side of the home in which Bradford lived and died. The plaque read:

This House Was the Home of
John Bradford
1749–1830
A Pioneer Settler of Lexington
First Printer of Kentucky
Co-Founder of The Kentucky Gazette
A Prominent, Public-Spirited and Useful Citizen.

THE BRUCE FAMILY AND OLD MRS. BRUCE

The Bruce family acquired the deed to the Hart-Bradford House on December 28, 1833, nearly three years after Bradford's death. John Bruce paid $4,400 for the property. The Bruce family had moved into the home soon after Bradford's passing. Rebecca Gratz Bruce was born in the Bruce home at 193 North Mill in June 1830. John Bruce was a business partner of Benjamin Gratz in the manufacturing of hemp until Bruce's death in 1836.

Across Second Street from the Bruce family was the home of the mother of the dashing General John Hunt Morgan. It has been said that the future Confederate general could have taken any belle as his bride, but his interests turned to Miss Rebecca Gratz Bruce. Rebecca "was intelligent, tender and lovable, with a soft round face and friendly eyes twinkling with gaiety and laughter." The couple exchanged vows on November 21, 1848, in the bride's family home. History has left silent the details of the nuptials, but it is entirely

General John Hunt Morgan, the Thunderbolt of the Confederacy, wed his first wife, Rebecca Gratz Bruce, in the Hart-Bradford House in 1848. *Courtesy of the University of Kentucky Libraries.*

possible that the couple exchanged vows in the same spot where, fifty-one years earlier, Henry Clay and Lucretia Hart were wed. (Some accounts differ and place the Bruce-Morgan nuptials at the nearby Christ Church.)

After their union, John and Rebecca moved into our subject property with the bride's mother, Margaret Ross Hutton Bruce. The couple remained there for an unknown period, but it is possible that their residency lasted until the eve of the Civil War. George W. Ranck wrote in 1872, "Just before the late war [the War Between the States, John Hunt Morgan] lived on the corner opposite his old home, in the house now occupied by Mrs. Ryland."

It is well known that during the War Between the States, Kentucky was a border state. Kentuckians fought for the Union and the Confederacy alike. The Bruce family was not immune to such divisions. While Rebecca Morgan's husband was nicknamed the Thunderbolt of the Confederacy, her brother wore the blue of the Union army.

Kentucky's status was reflected on the flags of both the Union and the Confederacy during the Civil War. Although Lexington was never the site of significant wartime hostilities, both Union and Confederate troops regularly passed through and occupied the city. Much of the war's activity

in Lexington centered on the "Little College Lot"— the land that would become Gratz Park.

On the eastern edge of the lot stood the Peter House. Dr. Robert Peter was appointed acting assistant surgeon at the United States General Hospital, which occupied Old Morrison, during the autumn of 1862. Since the beginning of that year, Dr. Peter's daughter, Frances Dallam Peter, kept a diary that has been described in *Window on the War* as a "valuable primary account enriched with numerous observations of social, political, and economic conditions in central Kentucky." The diary was bound in eight small books with a binding of thread, each being made from the supply sheets from her father's military hospital.

Frances was nineteen when she began her diary in January 1862. It was three days before Christmas that her diary referenced our subject home, which was then occupied by Mrs. Margaret Bruce, the mother-in-law of General Morgan. Rebecca Morgan had died during the previous summer after a long illness, likely both physical and psychological, following an 1853 miscarriage. On December 22, 1862, Frances wrote:

> *On account of some rumor about John Morgan that he was expected to come or send some of his spies here or something of the kind…They searched the houses of Mrs. Morgan, Mrs. Curd and old Mrs. Bruce. Nothing came of it, but today three of Morgan's men were caught and put in jail.*

Rumors of Morgan's arrival in Lexington prompted the search of the North Mill Street homes of both his mother and mother-in-law. Mrs. Bruce survived the war, but she passed away during the summer of 1868, at the age of seventy-nine.

LAURA CLAY

From the Bruce estate, Ann E. Ryland acquired the subject property for $10,000. Ann was one of six daughters born to Dr. Elisha Warfield, and another of these sisters was Mary Jane Warfield.

Mary Jane was married to Cassius Clay, an ardent abolitionist from Madison County, Kentucky, who would serve as the minister to Russia following an appointment by President Abraham Lincoln. Married in 1833, the couple's union was, by all accounts, strenuous at best.

Clay's autobiography, *The Life of Cassius Marcellus Clay: Memoirs, Writings, and Speeches*, described the void between the couple as having been caused, in part, by the gossip and manipulations of his wife's sisters, including Ann Ryland. On the other hand, much of history records Clay as being unfaithful to his wife. He admitted as much in an 1898 interview with the *New York Journal*: "I was practically divorced long before it took legal shape, therefore I considered myself free to love anybody."

The divorce did take "legal shape" when Clay petitioned the Kentucky courts on grounds that Mary Jane had left him while he was stationed in Saint Petersburg, Russia, and that he had remained abandoned by her for the statutory minimum period of five years. Under the law, such a lengthy abandonment warranted a petition for divorce. During much of this five-year period, Mary Jane Clay resided at the Gratz Park home of her sister, Ann Ryland. Mary Jane Clay brought along her adult daughter, Laura Clay. The divorce was finalized in February 1878.

Whatever the cause of their separation and ultimate divorce, the end found Mary Jane Warfield and her daughter without Cassius Clay and without a share of his property. They hardly found themselves penniless as members of the Warfield family, though the letter of the law would be equally as harsh on those without such a lineage. This was not lost on Laura.

Laura Clay was two days shy of her twenty-ninth birthday when her parents' divorce was finalized. An adult, Laura Clay would never marry, but would devote her life to the causes of suffrage and the equal treatment of women.

A decade after her parents' divorce, Laura founded the Fayette County Equal Rights Association "to advance the industrial, educational and legal rights of women, and to secure suffrage for them by appropriate State and National Legislation." The following year, Laura Clay helped to organize, and was the first president of, the Kentucky Equal Rights Association (KERA). She held the office of president until 1912.

According to *The Kentucky Encyclopedia*, KERA was responsible for victories such as the "protection of married women's property and wages, a requirement for women physicians in state female insane asylums, and the admission of women to a number of male colleges." Transylvania University, for example, became co-educational in 1889. And Kentucky women received the right to vote in 1912, albeit only in school board elections, years prior to the national adoption of women's suffrage.

In 1896, Laura was elected auditor of the National American Woman Suffrage Association (NAWSA). Through this organization, she volunteered extensively on suffrage campaigns throughout the nation. Laura ultimately

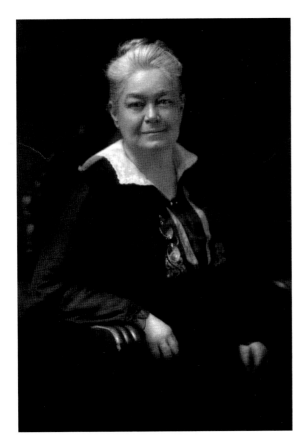

Laura Clay (1849–1941) was the first president of the Kentucky Equal Rights Association and a leader for women's suffrage. *Courtesy of the University of Kentucky Libraries.*

withdrew from both KERA and NAWSA in favor of the Southern States Woman Suffrage Association because only the latter advocated suffrage solely by amendments to the constitutions of each of the several states.

It is noteworthy that Laura opposed amending the United States Constitution to require suffrage at the federal level. Accordingly, Laura actively opposed the ratification of the Nineteenth Amendment. Her position on these matters stemmed from her strong beliefs in state sovereignty and out of a fear that the powers given to Congress by the Nineteenth Amendment "to enforce the provisions of this article" were overbroad and could result in Congress's intervention in state elections. Irrespective of Laura's position on the federal amendment, it was ratified and adopted in 1919.

The following year, Laura was a Kentucky delegate at the Democratic National Convention in San Francisco, California. At the convention, her

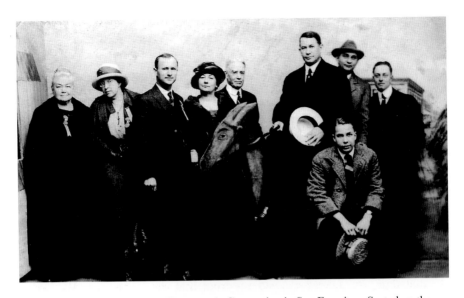

Laura Clay, far left, at the 1920 Democratic Convention in San Francisco. Seated on the donkey is Representative Alben Barkley. *Courtesy of John Rhorer.*

The site of the Hart-Bradford House as it appears in 2014. *Author's collection.*

name was placed for nomination for president. Although it would take sixty-four years before a woman would appear on a presidential ticket (and then, only as vice president), the nomination of Laura marked the first occasion where a woman was nominated at a political convention to serve as president of the United States.

When Ann Ryland died "at a ripe old age" in June 1892, she left her home at the corner of Second and Mill Streets to her two nieces: sisters Laura Clay and Anne Crenshaw (Crenshaw led the cause for suffrage in Virginia.). Laura acquired her sister's interest in the property and resided there for the balance of her years. She died in her home at the corner of Second and Mill Streets in June 29, 1941. She was ninety-two. On September 9 of the same year, the property was auctioned to the highest bidder. Proceeds from the auction were $13,425, a sum that helped to settle Laura's estate.

On March 8, 1955, the owner of 193 North Mill Street was R.A. Welch. On that date, the *Lexington Leader* reported that the "Thurman Wrecking & Lumber Co. today was granted permission to tear down the 20-room 'John Bradford Home,'[with] wrecking…scheduled to begin immediately." Immediacy was not an understatement. The following day, March 9, 1955, the *Lexington Leader* reported that the "deconstruction of this historic building" had begun. The demolition made way for a seventy-one-space surface parking lot that remains today.

Though the home of so many of Kentucky's notable persons was lost forever, the demolition did prompt a group of preservation-minded individuals to go about ensuring that the same fate did not befall the Hunt-Morgan House. That group, the Foundation for the Preservation of Historic Lexington and Fayette County, expanded its mission and is known today as the Blue Grass Trust for Historic Preservation.

The City of Lexington also took note and expressed its concern over the demolition by establishing zoning overlays so that certain historic structures and buildings might be protected. In 1958, Gratz Park was made Lexington's first historic district; at the time of this publication, there are fifteen.

Though once described as "one of Lexington's oldest, most historic landmarks," 193 North Mill Street remains only a parking lot; nothing has risen from its ashes. It can be said, however, that its demolition galvanized members of the community to the great task of preserving Lexington's historic and cultural resources.

2

CENTREPOINTE BLOCK

Half a century after the demolition of the Hart-Bradford House strengthened the resolve of Lexingtonians interested in historic preservation, another demolition once again galvanized a disparate group of activists. When the Centrepointe block was demolished, the former Athens of the West was forever changed. The block, located in the heart of Lexington's commercial core, is physically bound by Main and Vine Streets, to the north and south, and by Limestone and Upper Streets, on the east and west. The block once consisted mostly of mid-nineteenth-century commercial buildings. The Centrepointe moniker relates to the proposed development on the block and is not a historical term. When the historic structures on the Centrepointe block fell, many of their façades had been already covered or altered from their former glory, yet several of the structures stood ready for rehabilitation. Parts of the block had already faced the wrecking ball, but many historically significant structures remained.

That is, until July 23, 2008. On that date, demolition crews began the systematic process of razing the entire block. A proposal to build a forty-story mixed-use monolith on the block met significant hurdles. The collapse of the financial markets in 2008 was coupled with both the death of a key investor as well as a public outcry against the proposed design. All these circumstances worked against the developments proposed for the Centrepointe block.

For more than five years, the block stood empty. Along the way, grass seed was planted and four-plank fencing, reminiscent of the region's horse farms,

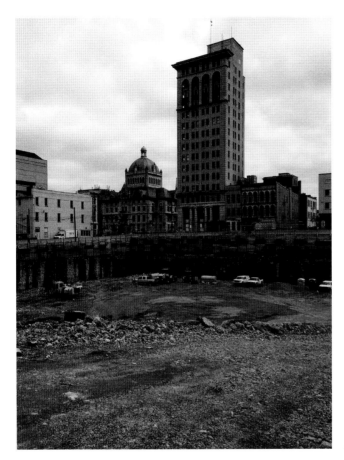

An excavated Centrepointe block in 2014 exposes an open view of two of Lexington's most significant landmarks, the old county courthouse and the city's first skyscraper. *Author's collection.*

created a privately owned park-like setting in the heart of downtown. At times, the space was opened for public events. Once, a nighttime polo match was even held on the grounds!

The first half of 2014 saw this midtown pasture ripped apart and the plank fencing removed. Earthmoving equipment dug deep, only yards away from where the Town Branch still flows, in order to create space for the proposal's underground parking. Above the parking garage will be a collection of buildings of varying heights and modern architectural styles. Although none will possess the monolithic scale first proposed, nothing can return the block to her historic past.

The fifteen structures of Centrepointe demolished in 2008 can never be recovered. Twelve of these buildings were proposed for listing on the National Register of Historic Places, but the registration couldn't

be completed before the contributing buildings were systematically torn down. Collectively, the block was significant. As noted in the registration form for inclusion, preservation consultant Elizabeth Heavrin noted that "compared to the other blocks on the south side of Main Street, this block has few intrusions and has maintained a far greater sense of its historical, pedestrian-oriented scale. It also remains a true four-sided block, thus expressing a richer, more multi-dimensional history than simply that of Main Street." This historic, multi-dimensional block contained several significant individual structures. Arguably, the most notable of these was the Morton's Store building that was located at the northeast corner of North Upper and West Vine Streets.

MORTON'S STORE AND ROW

The Centrepointe block was always intended to serve a commercial purpose. Commercial activity first appeared here in 1780. The oldest stretch of commercial structures still standing in Lexington in 2008 was known as Morton's Row. The three buildings that made up Morton's Row were erected in 1826 and each faced Upper Street. Of the three structures in Morton's Row, the Morton's Store building was arguably the most significant building of the twelve demolished in 2008.

Morton's Store building was described by architectural historian Walter Langsam in the Kentucky Historic Resources Inventory as "one of the oldest, most handsome, and on the exterior most intact of downtown Lexington's commercial buildings." At almost 5,900 square feet, the two-and-one-half-story, four-bay Federal-style commercial structure was of excellent proportion. Oriented toward Upper Street, it was best defined by a significant pediment marked by a semicircular lunette that spanned the structure's two middle bays.

The southern façade of Morton's Store building once faced Water Street. Most of this street disappeared decades ago with the expansion of Vine Street and the removal of railroad tracks, but Water Street was once one of Lexington's most significant roads. Seven windows opened Morton's interior to a southern exposure and allowed those inside to see the busy activity occurring along Water Street.

Asa Chinn, a local realtor and insurance salesman during the first half of the twentieth century, is noted for his photographic collection that is now

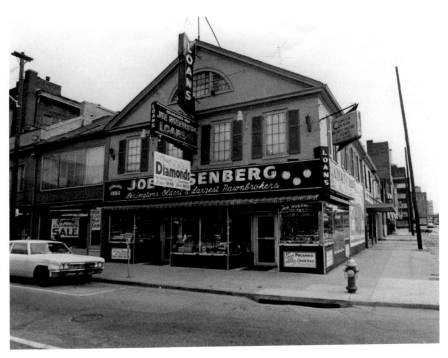

Dating to 1826, Morton's Store building was "one of the oldest, most handsome" of Lexington's commercial structures. *Courtesy of the University of Kentucky Libraries.*

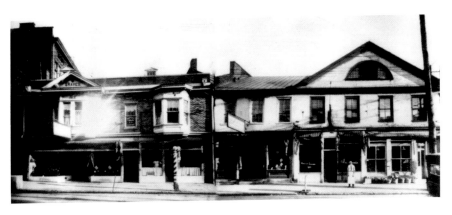

Morton's Row along South Upper Street, as seen through the lens of Asa Chinn, circa 1920. *Courtesy of the University of Kentucky Libraries.*

housed in the special collections of the University of Kentucky. His 205 prints presented a snapshot of Lexington in 1920–21 and were useful for his career as a realtor. Each image remains as an invaluable resource for discovering Lexington's past.

The entire Centrepointe block, including Morton's Row, was photographed by Asa Chinn. At the time of Chinn's photograph, circa 1920, Morton's Store was divided into two businesses. The image depicts a man in a tie and apron standing outside the Manhattan Restaurant. Writing on the restaurant's window suggests that a "regular dinner" at the Manhattan could be had for forty cents. W.O. Wash occupied the other half of Morton's Store.

Rosenberg's, an established Lexington pawn brokerage specializing in diamonds, moved into the location. Rosenberg's later expanded and remodeled the entire Morton's Store building in 1952, remaining in the building until shortly before the block was demolished, when it relocated once again to Main Street. Founded in 1896, the neon sign above the entrance to Rosenberg's proclaimed the store was "Lexington's Oldest Largest Pawnbrokers."

The two structures to the immediate north of Morton's Store completed Morton's Row. Both were also completed in 1826, and the complex held a variety of stores, restaurants and offices over the years. Chinn's photographs identified both a barbershop and a finance company as occupants. In the pediment of one structure, the name Graves appears, which reflects the post-1911 owner of the building, J. Arthur Graves. Graves had been "a dealer in fancy fruit and other delicacies in the old Market House." Similar lettering was visible on other buildings within the block in which Graves, Cox & Company, a men's clothier in Lexington from 1889 until 2014, was once located.

The namesake of Morton's Row was William Morton, who was one of Lexington's "earliest, wealthiest, and most philanthropic merchants," according to Langsam. Contemporaries referred to Morton as "Lord Morton," due to both his success and his aristocratic nature. He began his empire in 1787, with the opening of a general trading store. He later operated a tannery and served as president of the Kentucky Insurance Company, which was the first bank in Lexington. He helped to found First Episcopal Church (later Christ Church Episcopal) and donated the land on which that church was built. His residence stands along North Limestone Street as the centerpiece of what is today called Duncan Park.

When Morton died, he left a significant portion of his estate for a public school to be established. It would become Lexington's first public school in

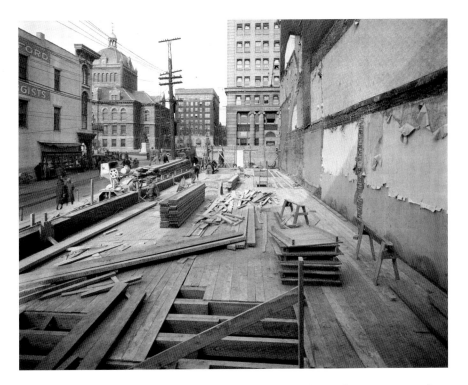

Construction in 1930 of the Lerner Stores' 150th location, at the southeastern corner of Main and Upper Streets in Lexington. *Courtesy of the University of Kentucky Libraries.*

an era when wealthy children attended private academies and those not born into privilege worked from an early age. The Morton School first opened in 1908, at the corner of East Short and Walnut Streets, as Lexington's first public high school. When a new Morton School was opened on Tates Creek Pike in 1938, the old school was abandoned. Within two years, that building was demolished by the local Sears, Roebuck and Company that was then expanding its operations in Lexington.

Immediately to the south of Morton's Row was an Art Deco, narrow, two-story structure that was constructed in 1930 by the Lerner Brother Incorporated of New York City. Opening in May 1930, the Lexington location of Lerner shops at the southeastern corner of Main and Upper Streets was the chain's 150th location. It would feature "ladies apparel at popular prices" according to the *Lexington Leader.*

In 2008, the façades along Upper Street appeared largely as they had in 1930, though other parts of the block had a partially toothless grin.

The Victim of an Earlier Demolition

As noted earlier, several historic structures on the block met their fate prior to the 2008 demolition. Among the most significant was the F.W. Woolworth Building, which had been individually listed on the National Register in 2002. Demolished in 2004, the building at 106 West Main was a "hybrid design of Art Deco and Streamline Moderne style." The Woolworth's five-and-dime brand began in Lancaster, Pennsylvania, in 1879 and became one of America's first chain stores.

In 1901, Woolworth's opened its first Lexington location. With its humble roots, the marketing strategy of Woolworth's was to appeal to the broadest possible customer base with its "Everybody's Store" slogan. In 1935, corporate policy was altered to allow goods to be sold at prices other than a nickel or a dime in part to improve corporate profits but also to bring a larger variety of goods to its stores.

Woolworth's continued to grow and prosper despite both the Great Depression and its higher prices. In 1948, the Lexington store moved from its old location at 268 West Main Street to the subject property, just a block away. The architectural style employed in the new structure added to the modern, progressive image sought by Woolworth's marketing team. It was also an image that other local department stores employed through new construction or at least new façades.

The grand opening for the new Woolworth's was on September 9, 1948. Pulling on the curved chrome handles of the wooden doors revealed terrazzo tile floors with an inlaid tile W, in the style of the corporate logo, to customers. A massive air-conditioned sales floor with fluorescent lighting overhead gave customers the sense of every modern amenity.

As was the case throughout the country, the 1960s and '70s were especially harsh on Lexington's downtown retailers. While in the early 1940s, Lexington's downtown boasted eight department stores and two dime stores, in addition to the many small retailers, the closure of the S.S. Kresge store in 1967 left Woolworth's as downtown's only major retailer.

This, too, came to an end in 1990, when Woolworth's left downtown Lexington after eighty-eight years of business. A decade later, there was a plan to turn the Streamline Moderne–style structure into an incubator for high-tech startups, but the burst of the tech bubble in 2001 ended the possibility. Other attempts were made to secure both a new tenant and sufficient funds to restore the historic retail center, but these also fell through. Woolworth's was demolished in the late autumn of 2004, despite the significant attempts of its owner to raise the $5 million necessary to renovate the old Woolworth's building.

SEVERELY ALTERED, YET SIGNIFICANT

Another structure underwent significant change during the twentieth century: the three-story brick building that once stood proudly at the southwestern corner of Main and Limestone Streets. Prior to demolition, it was most recently a Rite Aid pharmacy, with a façade dating to 1979. Yet its much older history dates to circa 1850.

Historic photographs show the building's great transformations over the years. The earliest of these shows the building standing prior to the Civil War and reveals the occupant to be a clothier. The handsome Greek Revival–style, four-bay house of commerce housed clothiers Louis and Gus Straus, from the turn of the nineteenth century into the twentieth. By 1944, the building was occupied by multiple businesses, including both Leed's (another clothier) and the previously mentioned Rosenberg's jeweler and pawn broker. The latter was located in this structure prior to its 1952 relocation to the far opposite corner of the same block.

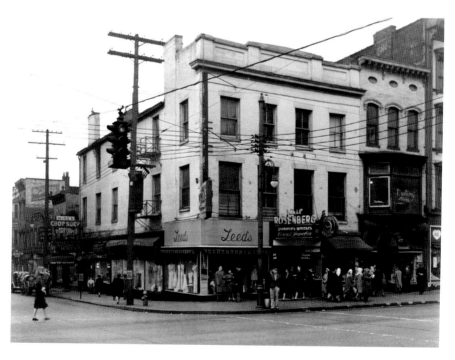

The building at 100 West Main Street predated the Civil War, and its Greek Revival–style façade was a familiar downtown sight until the mid-1940s. Photo circa 1944. *Courtesy of the University of Kentucky Libraries.*

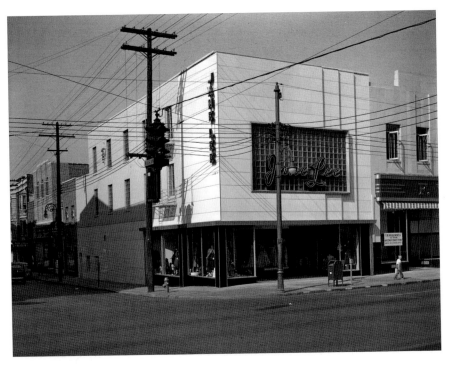

Adopting a more modern appearance, the façade of 100 West Main Street was dramatically altered on multiple occasions during the twentieth century. Photo circa 1948. *Courtesy of the University of Kentucky Libraries.*

By 1948, the Jane Lee Store, a women's clothier, had moved into 100 West Main Street. Adopting Woolworth's strategy of presenting a modern, progressive image, Jane Lee's Main Street façade was dramatically altered. Despite the building's age, the significant alterations to the building's façade rendered it a "non-contributing" building in the proposal to put the block on the National Register of Historic Places.

The buildings mentioned in this chapter are only a handful of those that once stood on this important block of Lexington's commercial history. Importance and significance could not save this core block that was viewed by some as just a cluster of "old buildings." In the end, none of the structures survived, and the entirety of this centrally important block of Lexington's history was lost.

3

PHOENIX HOTEL

By "succession the [Phoenix Hotel was the] oldest hostelry in the whole western country," according to its entry in the *Kentucky Encyclopedia*. For decades, the hotel was physically—and by activity level—the center of the city. The hotel occupied the southeast corner of what is now East Main and South Limestone Streets. And within its walls and passing its doors, the histories of both Lexington and America unfolded. For those looking at Lexington's past, references to the Phoenix Hotel seem to appear more than any other place or person. In other words, the significance of this old hotel cannot be overstated.

The politics of the day were once hashed out in the smoke-filled parlors of the Phoenix Hotel. Social clubs and religious groups hosted their meetings here. The rich and famous ate in the dining rooms of the Phoenix. And neither death nor scandal escaped the legacy of the Phoenix Hotel. That legacy began long before the construction of the building that was demolished in 1981.

The hotel did not consist of simply one building. It was modified and grew over time, though the hotel was never such a massive structure that it consumed an entire block. The early taverns were replaced after fires in 1820 and 1879 required the hotel to be rebuilt. The low-rising hotel was expanded in 1914 by the construction of an eight-story hotel tower in place of an old livery.

When that tower opened, the Phoenix Hotel was advertised as "fire-proof." This would have been an accomplishment for the old hotel that had been historically plagued by fire. After all, it was called the Phoenix because

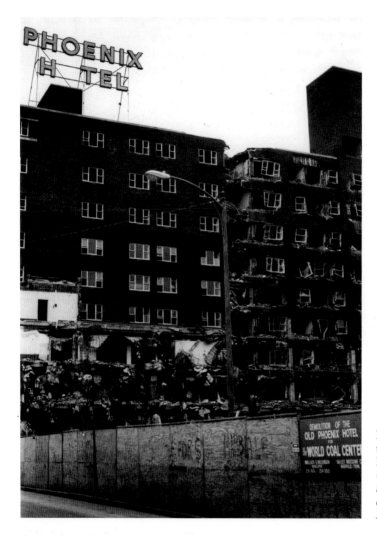

Demolition of the Phoenix Hotel in 1981. *Courtesy of the University of Kentucky Libraries.*

it rose from the smoldering ashes of those earlier hotels and taverns. The 1914 promise of a "fire-proof" hotel must have been quite something, and one cannot think of such a claim without remembering that an iceberg sank the unsinkable *Titanic* just a short time before.

Yet it was not fire that would ruin the final Phoenix Hotel. Instead, the building's fate came in 1981 from the swing of a wrecking ball so that the World Coal Center could be constructed.

Wallace Wilkinson, who would later become Kentucky's fifty-seventh governor, acquired the hotel and its underlying land. The World Coal

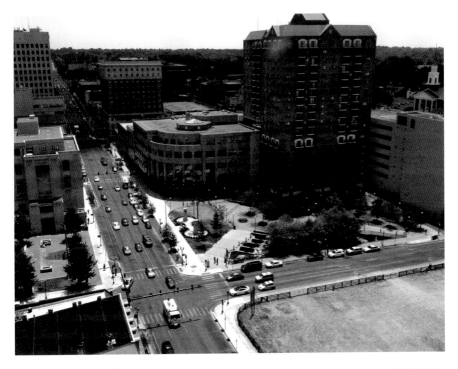

A view of Phoenix Park and the Lexington Public Library on the land once occupied by the venerable Phoenix Hotel. *Author's collection.*

Center was intended to house the corporate headquarters of multiple coal companies that mined the hills of eastern Kentucky. As originally planned, the World Coal Center would rise to a height of forty-one stories. If built, it would still reign as the tallest building in Lexington.

But by 1984, it had not yet been constructed, and the project's scale had been reduced to a height of only twenty-five stories. In that year, Wilkinson proposed a temporary park to occupy the rubble-filled lot that littered Main Street for the few intervening years. It was important that something be done because, the following spring, many visitors would descend on Lexington to attend the 1985 Men's NCAA Tournament, a move echoed by Centrepointe developers with their sod and fencing prior to the 2010 World Equestrian Games.

That temporary park, known as Phoenix Park, was joked to have risen from the ashes of the great hotel. In part, this is true as some of the large boulders in the park's fountain feature are remnants of the old structure. The reality of that joke has survived along with the still-extant park.

But before any phoenix could rise, the site was home to Postlethwait's Tavern.

Captain John's Tavern

In 1797, Captain John Postlethwait opened his tavern and inn on Lexington's Main Street. Some accounts report that Postlethwait's was situated on the site of an even earlier tavern started by Captain James Bray some twelve years earlier. This, however, is a disputed claim.

Captain Postlethwait had a reputation for good hostelry. The native of Carlisle, Pennsylvania, was born in 1769, before arriving in Lexington in 1790. He was too young to have served in the Continental army in the battle for America's independence from Great Britain, though several histories include reference to his service in that conflict. That military service would be properly attributed to John's father, who was a captain in the Pennsylvania line during the American Revolution.

Instead, Postlethwait acquired his title of "captain" as commander of the local militia—the Lexington Light Infantry Company—which was ultimately under General Charles Scott's command. General Scott, a veteran of both the French and Indian War and the Revolutionary War, would become the fourth governor of Kentucky. Postlethwait married Mary Scott, the general's daughter. It cannot be underestimated how this connection proved to be a key part of Postlethwait's success.

The "low rambling log house" called Postlethwait's Tavern was "equipped with the finest cherry and walnut furniture that skilled workmen could turn out." It was a "cheerful place to halt after the vicissitudes of early day travel" with "game and fowl, together with home-grown Kentucky produce" being served. Here, "in the glow of the log fires and candles…questions of politics, education and, to those participating, the all-important subject of racing and the development of the great breeds for which Kentucky is famous."

The accommodations offered at Postlethwait's were unrivaled, yet Postlethwait himself offered the primary appeal of his tavern. He was described as a "suave speaker" having a strong physical presence and being a "fantastical figure in the matter of dress." Above these things, his ability to make and hold "friends in all walks of life" was certainly a favorable trait. This was true in the early nineteenth century as much as it is true today.

As if to test his personality's effect on the tavern's business, Postlethwait turned the operation of the tavern over to Joshua Wilson in 1804. Under Wilson's hand, Postlethwait's Tavern's prominence subsided. Traveller's Hall soon rose to assume the mantle of Lexington's most important inn.

Though the old Postlethwait inn decreased in prominence during Wilson's management, it did grow physically; Wilson oversaw the construction of a two-story addition. Also during this time, in May 1805, Postlethwait's most notorious resident lodged here. Aaron Burr, the former vice president of the United States, stayed here. The preceding year, Burr mortally wounded Alexander Hamilton in their infamous duel. But Burr's infamy was still growing. Though we can only speculate what took place during Burr's visit to Lexington in the late spring of 1805, we know that his stay was a layover en route to New Orleans. Thereafter, he spent the summer speaking against the United States.

Although Burr would travel back through Lexington over the following eighteen months, the location of his lodgings on subsequent trips is unclear. One might suppose that he continued to stay in the familiar Postlethwait's where he lodged in 1805. According to the *Kentucky Gazette*, in late October 1806, Burr's visits garnered a good deal of public attention: "public curiosity [is] still on tiptoe relative to Colonel Burr's visit to Lexington."

In 1809, the affable Postlethwait recommenced management of his tavern and inn. Almost as quickly, the inn resumed its place as the town's most significant tavern. Postlethwait became one of the earliest victims of Lexington's first cholera epidemic, dying in 1833. The Postlethwait family, however, would remain involved in hostelry management throughout the region for years to come.

A PRESIDENTIAL VISIT

In 1819, the nation's independence was celebrated in Lexington, Kentucky. At the time, Mr. Keen managed the inn that had previously been under Postlethwait's name. Waking that morning at Keen's Inn was President James Monroe. The president's entourage occupied the entirety of the thirty-eight-room hotel. President Monroe was in the midst of his Grand Tour of the South, which followed similar tours he conducted in other regions of the country during the preceding two years.

Monroe would stay in Lexington for a few days. General Andrew Jackson had joined the Grand Tour during its stop in Nashville, Tennessee, and continued with the president's entourage to Lexington. On their arrival in Lexington, the president and General Jackson were "escorted to Keen's

tavern by old infantry, several rifle and artillery companies, and a large and enthusiastic crowd of citizens" according to George W. Ranck's *History of Lexington*. Ranck further described the presidential visit:

> *Salutes were fired both when they entered town and when they arrived at the tavern. They visited the university and were addressed by Dr. [Horace] Holley and some of the students after which they went to [portrait artist Matthew] Jouett's studio. The next day they attended the Fourth of July festival at Dunlap's. Sunday they attended church. Monday they were given a public dinner at Keen's tavern by the citizens who addressed the President through Colonel Morrison. The distinguished guests left town the next day.*

The visit of the president and his entourage must have caused quite a bit of excitement for all Lexingtonians. Some sources also suggest that General Zachary Taylor accompanied the president's entourage; if so, it marked a moment when three presidents were in Lexington—and staying at Postlethwait's inn—at the same time.

Fire Claims Postlethwait's Tavern (Twice)

On March 3, 1820, the old hostelry succumbed to a devastating fire that would change the identity of this Lexington institution. On the day following the fire, a news article in the *Lexington Public Advertiser* suggested the hope that a hotel would "soon rise, like the Phoenix from its ashes."

> *Fire! Fire! Fire! On yesterday about 3 o'clock in the afternoon, this town was again alarmed by this dreadful cry: which is ever alarming to the feelings of man, and more so of late from the many, and dreadful visitations which we have of late experienced. The superb tavern had taken fire in the upper story of its corner, on Limestone Street; and had so far progressed, that every effort to quell it, was useless, until the greater part of that valuable building was consumed. Fortunately a part has been preserved by the activity of many citizens, and the aid of two or three of our Fire Companies. Thus, in the course of a few hours, the prospects of a large family have, for a time, been blasted; and an Hotel distinguished for the comforts which it afforded to the way-worn traveller, is in ashes. We hope, however, it may soon rise, like the Phoenix from its ashes, and that this misfortune will be but the*

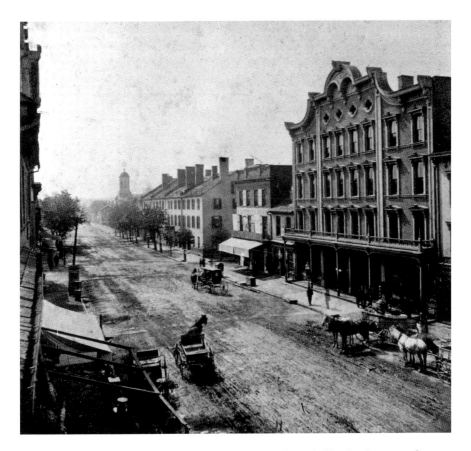

Lexington's Main Street prior to the Civil War, with the Phoenix Hotel at its center. *Courtesy of the University of Kentucky Libraries.*

commencement of an era of good fortune to its proprietor. It is not known whether the fire was produced by accident or not.

On January 9, 1821, Keen's New Hotel reopened "on an improved and more extensive plan." From the *Public Advertiser*'s suggestion, the hotel would assume that mythological name—the Phoenix Hotel—of the bird that regenerated from the ashes of predecessors.

The Phoenix Hotel was used for many other purposes, including headquarters for General William "Bull" Nelson, General Braxton Bragg and General Kirby Smith during the American Civil War. Additionally, the Morgan's Men Association was formed at the Phoenix Hotel after the reinterment of General John Hunt Morgan on April 17, 1868, in the Lexington Cemetery.

The low-rising Phoenix Hotel opened in 1880 after the 1879 fire; an eight-story addition was erected in 1914. *Courtesy of the University of Kentucky Libraries.*

During the May 1879 racing season at the Kentucky Association Track, a party was held in a ballroom at the old Phoenix Hotel. During the party, a "second fire visited the already ancient tavern on May 14," burning the hotel. Again, the Phoenix would rise from its own ashes. As the smoke cleared, work began on the new Phoenix that fronted 154 feet on Main Street and 180 feet on Mulberry Street (now Limestone Street), according to the *Lexington Transcript.*

POLITICS ARE THE DAMNEDEST

One of the great moments in the Phoenix's storybook involves a speech delivered to a group of legislators by Judge James Mulligan. James Hillary Mulligan was the son of Dennis Mulligan, an Irish Catholic political boss whose machine swiftly controlled much of Kentucky. Dennis Mulligan gave his son a home

on Rose Street as a wedding gift. The residence, known as Maxwell Place, has served as the home for the president of the University of Kentucky since it was purchased from the Mulligan estate by the college in 1917.

During his own career, James Mulligan reached high levels of political power, including a stint as speaker of the house in Kentucky's general assembly. He preferred, however, the title of "judge" in deference to the position he attained in his legal career.

Mulligan also served as the consul general in American Samoa and held positions in the United States Treasury Department. The *Lexington Leader* wrote that he was "a shrewd looking man, even through his spectacles, and has an air of always being alert. The Judge loves to debate, has a penchant for thoroughbreds, does not care for society, and can make a better humorous or satirical speech than any man in the state of Kentucky."

It was that humorous and satirical spirit that provided Mulligan his greatest legacy. In the ballroom of the Phoenix Hotel in February 1902, Mulligan spoke before a number of state legislators. To conclude his toast, "he drew from his pocket, as if drawing a deadly weapon, dangerous-looking type written manuscript, and peering over his glasses with a smile of satisfaction that amounted almost to a leer, read" his poem, "In Kentucky":

> *The moonlight falls the softest*
> *In Kentucky;*
> *The summer's days come oft'est*
> *In Kentucky;*
> *Friendship is the strongest,*
> *Love's fires glow the longest;*
> *Yet, a wrong is always wrongest*
> *In Kentucky.*
>
> *The sunshine's ever brighest*
> *In Kentucky;*
> *The breezes whisper lightest*
> *In Kentucky;*
> *Plain girls are the fewest,*
> *Maidens' eyes the bluest,*
> *Their little hearts are truest*
> *In Kentucky.*

Life's burdens bear the lightest
In Kentucky;
The home fires burn the brightest
In Kentucky;
While players are the keenest,
Cards come out the meanest,
The pocket empties cleanest
In Kentucky.

Orators are the grandest
In Kentucky;
Officials are the blandest
In Kentucky;
Boys are all the fliest,
Danger ever nighest,
Taxes are the highest,
In Kentucky.

The bluegrass waves the bluest
In Kentucky;
Yet bluebloods are the fewest
In Kentucky;
Moonshine is the clearest,
By no means the dearest,
And yet, it acts the queerest,
In Kentucky.

The dove's notes are the saddest
In Kentucky;
The streams dance on the gladdest
In Kentucky;
Hip pockets are the thickest,
Pistol hands the slickest,
The cylinder turns quickest
In Kentucky.

Song birds are the sweetest
In Kentucky;

The thoroughbreds the quickest
In Kentucky;
Mountains tower proudest,
Thunder peals the loudest,
The landscape is the grandest—and
Politics—the damnedest
In Kentucky.

A wonderful poem that highlights the uniqueness of Kentucky, it was the final verse, and specifically the reference to politics being "the damnedest," that has drawn the most attention over the course of the century that followed.

THE GRAND PHOENIX

Twelve years after Mulligan delivered his oratory, an eight-story hotel was erected alongside the circa 1880 Phoenix Hotel. The new Phoenix Hotel opened in 1914 and featured ninety-two rooms. Several additions and modifications would be made to the hotel as it expanded over the next century to include several hundred rooms. In the decades to follow, it was this new Phoenix Hotel that was advertised as being "fireproof."

The Works Progress Administration published a guide to *Lexington and the Bluegrass Country* in 1938. The publication revealed that the Phoenix had become quite different from the hostelry options that once occupied the site:

A modern hotel, mecca of thoroughbred horsemen, stands upon the site and follows the traditions of Postlethwait's Tavern, best known of Lexington's hotels. A painting of the fabled Phoenix greets the visitor as he enters the lobby. The walls of the lobby and lounge are hung with likenesses of the great Bluegrass thoroughbreds that have made American turf history. In the new coffee shop, where the ballroom was formerly located, hang plaster medallions of Kentucky's famed John Filson, Henry Clay, John C. Breckinridge, Ephraim McDowell, Cassius M. Clay, John Fitch, Simon Kenton, Daniel Boone, Isaac Shelby, Abraham Lincoln and others. Tall windows reaching to the ceiling, give the room the gracious southern charm it has always possessed. The dining room, just back of the lobby, is newly decorated in the early English tavern style. Beside a column near the desk in the lobby stands a highway marker that, long ago, served to guide travelers

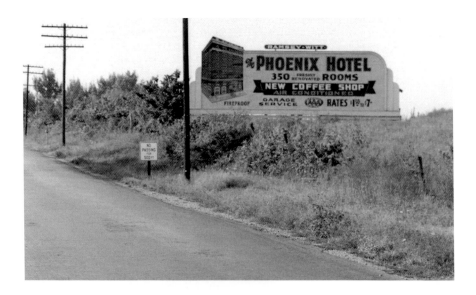

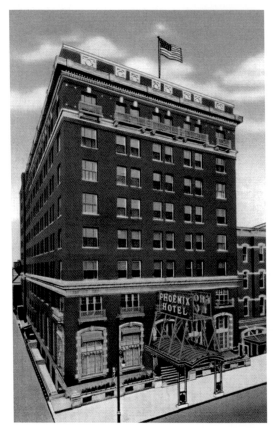

Above: A Lexington-area roadway in 1939 with a billboard advertising the "fireproof" Phoenix Hotel and its 350 "freshly renovated" rooms. *Courtesy of the University of Kentucky Libraries.*

Left: A postcard of the section of the Phoenix Hotel that was constructed in 1914 and demolished in 1981. *Courtesy of LexHistory.*

*over the old Maysville Pike between Lexington and the Ohio River, keeping
the oldest traditions of Lexington alive in a setting of the present.*

AT THE COFFEE SHOP COUNTER

One southern "tradition" came to a front at the coffee shop counter of the
Phoenix Hotel. During the 1960s, the civil rights movement sought fair
and equal treatment for African Americans. Throughout the country, and
especially in the southern states, discriminatory practices prevented equal
accommodation and service to those of color. Lexington was not immune,
and the Phoenix Hotel witnessed this kind of discrimination firsthand.

The most noted incident of such discrimination at the Phoenix Hotel
occurred in October 1961. The Saint Louis Hawks and the Boston Celtics,
the two teams that had vied earlier in the year for the NBA championship,
were to face off at Memorial Coliseum in a pre-season matchup.

A few hours before tipoff, several black players on the Boston Celtics roster
were refused service in the coffee shop at the Phoenix Hotel. As a result, four

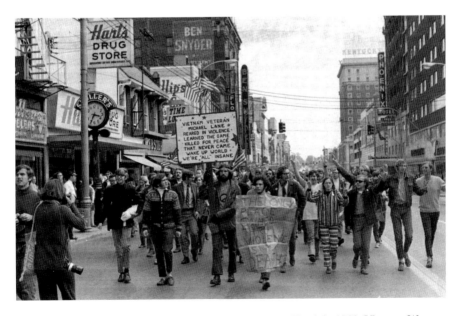

Among the many historic scenes witnessed by the Phoenix Hotel, in 1969, Vietnam War
protestors marched past the hotel. *Courtesy of the University of Kentucky Libraries.*

players boycotted the Lexington game and left town. Until that time, black athletes were expected to simply ignore acts of discrimination and play on. The quartet who left town and boycotted the game was made up of Bill Russell, K.C. Jones, Sam Jones and Satch Sanders. All four were eventually inducted into the Naismith Memorial Basketball Hall of Fame.

The incident garnered much attention in the press and continues to be cited as a significant event in Bill Russell's lifelong commitment to the dignity of all people. When presenting Bill Russell with the Presidential Medal of Freedom in 2011, President Obama recalled the event without naming any names: "When a restaurant refused to serve the black Celtics, he refused to play in the scheduled game."

As for the game itself, the Saint Louis Hawks soundly defeated the undermanned Boston Celtics, 128-103. Once united, the Celtics completed the regular season as victors in the NBA Finals and with a final record of 60-20.

NOT TO RISE AGAIN

As one would expect from its inclusion in this book, there came a time when the Phoenix would not rise again. The significant history of this place would not be enough to save her. In 1972, plans were revealed to remodel and update the once-grand Phoenix Hotel. But these plans went "down the drain" in early 1973, as reported in the *Lexington Leader*. The following year, the Phoenix would close, ending 177 years of tradition. The *Lexington Herald-Leader* offered this fitting obituary for the storied centerpiece of Lexington's history: "Like the Greek bird for which she is named, Lexington's gracious "old lady," the Phoenix Hotel, has risen from her ashes over and over to keep a bit of southern in a city which once abounded with it."

4

UNION STATION

The term Union Station might conjure, for some, imagery of patriotic zeal and rampant nationalism. The Union forever! Hurrah!

But the union for which railroad companies named their joint terminals simply described the coming together of the various railroad companies and their lines into one place. By creating a united station, or union station,

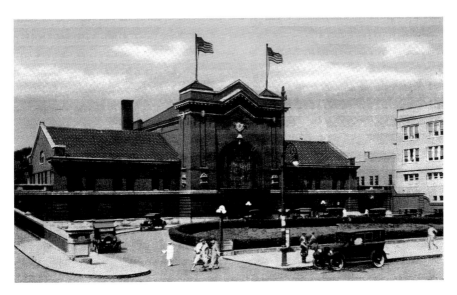

A postcard, circa 1917, of the Union Station in Lexington, Kentucky, as seen from Main Street. *Courtesy of LexHistory.*

among the railroad companies, the transfer between trains was made easier, thus enhancing the experience for passengers. Ultimately, the concept made travel by rail an even more desirable option.

Railroads did not always want to participate in these alliances. The Cincinnati Southern Railroad, for example, constructed a separate depot in Lexington apart from the Union Station. Reasons varied across the country for why a railroad company might not join into a union station, and the Cincinnati Southern had its own reasons for its decision.

Discussion of whether to construct a depot among multiple rail companies was first noted in the *Lexington Leader* in 1889. Discussion of the depot was frequent in those days, and the newspaper reported on this, observing that the "question of location" seemed to involve the greatest debate.

A QUESTION OF LOCATION

The same *Lexington Leader* article, dated February 27, 1889, noted, "it is believed that the people of the West End will make a determined effort to secure it." But on March 24, 1889, the *Lexington Daily Transcript* reported that the "East Side of town wants the Union Depot to be located there." By June, the site of the old Harrison School building was the center of conversations about a location for a union station. The old Harrison School remains standing on the south side of Main Street, between Jefferson and Old Georgetown Streets.

In 1891, the *Lexington Leader* reported that a new "scheme to build a Union Depot" was underway. The story was breaking news having "just come to the knowledge of *The Leader*" despite the subject having "been quietly talked of" by railroaders for some time. The article further noted that this proposed Union Station would, in terms of both "convenience and magnificent of scale, surpass anything yet broached." And yet it, too, would not be built.

A decade later, in 1901, discussion about the location for the Union Station focused on the site of the old Main Street Christian Church that was now a public space known as the Auditorium. The Main Street Christian Church had been built in 1842 at the southwestern corner of Main Street and Ayres Alley. The church relocated (and was renamed) to the present-day Central Christian Church on East Short Street, due to the inadequate size of the Main Street facility. It was in its old location on Main Street that Henry Clay once presided over a significant theological debate between Reverends Alexander Campbell and N.L. Rice. The subject of the debate was Christian baptism,

and it was a significant event in the history of the Reformation Movement. The religious significance of this location prompted many to lament the structure's transformation into a secular auditorium. In 1898, J. Soule Smith wrote:

> *Another most picturesque feature of Lexington is the old Main Street Christian Church, still standing, but by a strange mutation of fate, with fresh paint on its hoary front, and new fresco on its walls, it comes this day a Variety Theatre, and will open to burlesque before I finish the page on which I write....Peter and Paul give place to comedians and Coryphees.*

The opposition of the faithful to the Auditorium caused many to view the ultimate demolition of this once house-of-God as a good thing. Many, however, were not committed to converting the location into the site for the rail depot. Continued debate and arguments for constructing the union depot on the western side of town delayed any progress from occurring until 1905.

That year, three rail companies joined together to construct a union station in Lexington. Two of these companies—the Chesapeake and Ohio (popularly known as the C&O) and the Lexington and Eastern (the L&E)—already maintained a depot together behind the Phoenix Hotel. The Louisville and Nashville (the L&N) joined the other two to organize the Union Station Company.

On February 12, 1905, the Union Station Company acquired the old Main Street church property for $35,000. Almost in glee, the *Lexington Leader* reported:

> *The most advanced step toward the realization of the dream of the "Greater Lexington" taken here in twenty-five years was taken Saturday night. It was the purchasing of a site for a union depot by three great and prosperous railway companies whose lines enter the city, with a view to erect a handsome, commodious, comfortable and creditable stopping and starting place for the traveling public instead of the two cramped and unsightly shacks that have for years in a meager way answered this purpose.*

The Union Station Company anticipated the large project would cost approximately $200,000 and acquired adjacent properties throughout the year. As with so many projects, this estimate was massively under budget. An initial part of the project required the erection of a viaduct in place of Ayres Alley, to create a raised roadbed over the new tracks. The Central State Bridge Company of Indianapolis was hired to build the new viaduct that would run from Main Street to High Street. It was originally constructed

to be a "safe, convenient and popular" improvement over the older Ayres Alley, but the resulting viaduct was just too impressive to be labeled an alley. The road assumed the name of Harrison Street. A short stub of Ayres Alley remains under the viaduct, and Harrison Street was renamed after Dr. Martin Luther King in the late 1980s.

A Magnificent Structure

By late 1905, work had begun on the foundation for the new Union Station. The Columbus, Ohio–based architectural firm of Richards, McCarty and Buford was hired to design Union Station. The firm also designed the Security Trust Building and the City National Bank Building, both in Lexington. Some sources suggest that the architectural design of Union Station was a joint effort between the firm from Columbus and the New York City firm of McKim, Mead and White, but this is inaccurate. Stanford White of the New York City–based firm did design Lexington's first skyscraper, the Fayette National Bank Building, but wasn't involved in the design of Union Station.

The source of confusion likely stems from a *Lexington Leader* article, dating from January 1907, wherein a description of the Union Station's façade noted that its entrance was "almost an exact reproduction in design of the Washington Arch in New York, one of the masterpieces of Stanford White," a reference that has been misinterpreted over the course of a century to attribute the Union Station's design to the notable New York firm. It should also be noted that the thought of Union Station's entrance being an "exact reproduction" of New York's triumphant Washington Arch is an exaggeration made only by one who had never seen the New York landmark.

The Hendricks Brothers and Company was awarded the contract to build. This is an unsurprising fact given the number of contracts in the city awarded to that prestigious company during the early twentieth century. The resulting Union Station was a site to behold. When it opened in August 1907, it was described in the *Lexington Leader* as a "magnificent structure. All the lights inside and on the front walks and under the sheds turned on at 7 o'clock Sunday night."

Local historian William Ambrose gave this description of the station's interior: "The lobby was located in the center rotunda (fifty by eighty feet, with a central dome fifty feet high), with a Roman arch ceiling and six oak waiting benches. Off the lobby were the ladies' retiring rooms, which included a dressing room and toilets for the women passengers. In addition,

off the lobby were the men's lounges, which included washroom, toilets and smoking room. On the east end of the lobby were the separate colored waiting rooms, with a separate entrance." It was a magnificent Lexington landmark that greeted and sent away those who had business there.

A SOJOURN VIA UNION STATION

Like the Phoenix Hotel, the Union Station was a gateway for travelers voyaging into Lexington. Many of Lexington's stories from the first half of the twentieth century can be told through Union Station.

The great archway over the depot's entrance saw young men arriving for military training at the university, prior to both World War I and World War II. Their emotions, as well as those of their mothers, wives and "lady friends" who watched their uniformed boys board the rails for destinations unknown, all were part of the experiences witnessed at Union Station.

And then there was the excitement that followed the return of a train from New York City in late March 1948. In New York's Madison Square Garden,

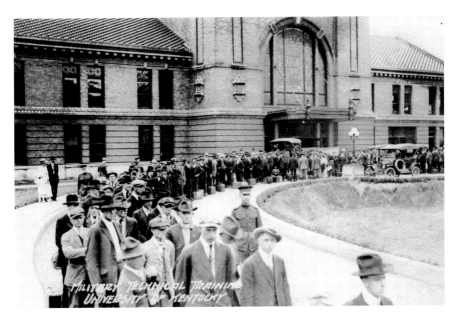

Soldiers assigned to the University of Kentucky for training arrived at Union Station during World War I. *Courtesy of the University of Kentucky Libraries.*

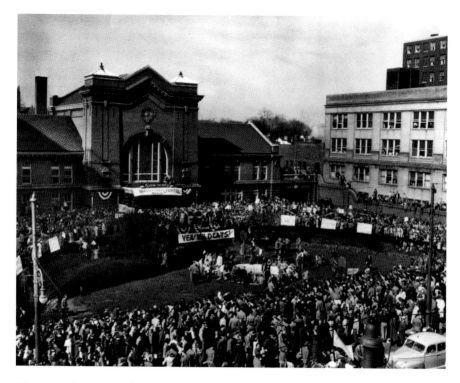

The city of Lexington celebrates the victorious Kentucky Wildcats after they returned from winning the NCAA Tournament in 1948. *Courtesy of the University of Kentucky Libraries.*

the University of Kentucky Wildcats had just knocked off the Baylor Bears in the school's first NCAA basketball national championship. Outside Union Station, an excited city proclaimed it the "Year of the Wildcat" when the basketball team returned victorious.

At its peak, Union Station enjoyed some twenty-six daily passenger trains. But the American traveler had largely left the rails in favor of his own automobile, counting on his own navigation skills rather than those of the train's conductor. Union Station's slow decline ended on May 9, 1957, when the Chesapeake and Ohio's George Washington left Union Station for the final time. This site had witnessed a half-century of Lexington's history. In three years, the old Union Station was demolished, with a parking garage and police headquarters replacing it. And though a historic marker notes the site as being the location of the Main Street Christian Church, nothing pays homage to the half-century of rail history that once dominated the streetscape.

SOUTHERN RAILWAY PASSENGER DEPOT

D escending the southbound hill on South Broadway toward the railroad underpass, one cannot help but take note of the old hotel that sits atop the hill on the left. Though the three-story Scott Hotel has been in various states of repair and disrepair for all of recent memory, it remains an impressive structure.

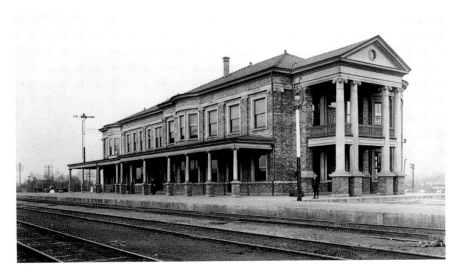

An early portrait of the Southern Railway Depot in Lexington near the road to Harrodsburg. *Courtesy of the University of Kentucky Libraries.*

The old Scott Hotel located across the Harrodsburg Road from the site of the old Southern Railway Passenger Depot. *Author's collection.*

It was a "railroad hotel" located across the highway from the old Southern Railway Depot. The depot once mightily stood atop the hill on the right when traveling south.

Both the hotel and the depot were constructed in the first decade of the 1900s, and both suffered an end, of sorts, in 1992. For the Scott Hotel, ninety-five housing code violations forced condemnation of one of Lexington's oldest hotels.

The wrecking ball found the old depot after a decade-long struggle for its preservation and reuse. The Scott Hotel remained. In 2014, it was undergoing further renovations.

THE FOURTH RAIL

The advent of the railroad in the decades before the Civil War transformed America's economic model and landscape. Once the war was concluded,

many miles of rail were laid out across the nation. Competing rail companies built their own networks to carry goods and passengers alike.

In Lexington, several chartered railroads resulted in myriad lines and depots dotting the city. The Cincinnati Southern Railroad became the city's fourth line in 1877. In so doing, the Cincinnati Southern actually acquired, in 1874, the right-of-way of the defunct Lexington and Danville Railway.

In 1868, the City of Cincinnati lobbied those in the Ohio statehouse for the ability to own its own railroad with the idea that such a rail line would transcend into the southern states from the Queen City. This lobbying campaign was necessary because Ohio's 1851 constitution prohibited municipalities from owning railroad stock. The successful campaign enabled Cincinnatians to vote on a bonding proposal.

On June 26, 1869, voters approved the $10 million bonding project by a ten-to-one margin. Construction began a few years later, but costs quickly overran original estimates. By 1876, Cincinnati's leaders asked voters for an additional $6 million in bonds. This vote was somewhat closer: 21,433 to 9,323. This additional $16 million investment enabled the line to reach Lexington. The first passenger train along the Cincinnati Southern Railroad traveled from Ludlow, in northern Kentucky, to Somerset, Kentucky, on July 23, 1877. A few weeks later, freight trains began to utilize the tracks.

But the original promise of the Cincinnati railway transcending the southern states still had not been reached, and the railroad was again running short of funds. Opposition to the railroad had mounted such that when a third vote for funding occurred in May of 1878, it was narrowly defeated by only 170 votes out of over 20,000 cast.

The loss at the polls was not a permanent setback. The municipal railroad quickly pledged to the voters that the $2 million requested in the lost vote would be the maximum sought to complete construction. This requirement was added to the measure when voters returned to the polls in August 1878 and approved the additional bonding for the Cincinnati Southern.

On February 21, 1880, a freight train traveled the completed Cincinnati Southern line from the Queen City to Chattanooga, Tennessee. The distance travelled was 337 miles. On March 8, a passenger train followed, and the rails would continue to carry both people and goods for decades to come.

Selecting and designing the path of the railroad accounted for the delay in the early years of the railroad. In early 1870, Tennessee authorized the Ohio-based railroad to erect rails within its borders, but Kentucky didn't follow suit until the following year. This may have been, in part, due to the dispute over the course the Cincinnati Southern would take through Kentucky. Initially,

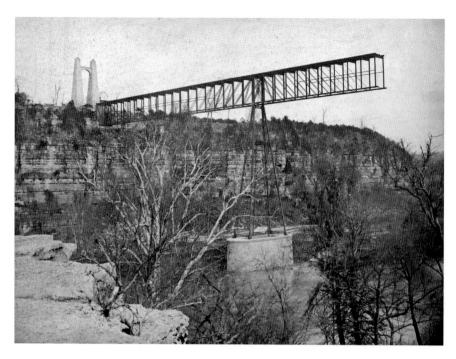

When completed in 1877, the High Bridge of the Cincinnati Southern Railway was billed as the highest bridge in the world. It connects Jessamine and Mercer Counties over the Kentucky River. *Courtesy of the University of Kentucky Libraries.*

the railway was going to pass through Louisville. However, Louisville was not interested in being included on the route, prompting some derogatory words about the River City to be printed in the *Cynthiana Democrat* in February 1870:

> *The country traversed is willing and more than willing, but here comes in the mean envy of a second rate city that happens to be on our side of the river, to oppose it, like a dog in the manger…Cincinnati has as many Kentuckians, and friends of Kentuckians, among her people as has Louisville, the little snob.*

The rail line would instead traverse through the first-rate city of Lexington. On July 23, 1877, the first train arrived in Lexington. The following day, the "first train in Cincinnati Southern RR arrived in the city yesterday on time. Consists of 5 elegant cars," said the *Lexington Press.*

The "opening of [the] Cincinnati Southern Railroad has increased all business in south end of town, hotel, boarding house and stores opening

up," according to the *Lexington Press* just two weeks after the first train arrived in Lexington. This prompted Lexington's leaders to vote to widen South Broadway from Winslow Street to the tracks. Through the rails, Lexington was continuing its transformation and growth.

THE DEPOT

The Cincinnati Southern Railroad erected its first passenger station in 1877, but it was demolished in the fall of 1892, after a new depot was constructed earlier in the year. That new depot was grand in its own right, but it burned on February 7, 1906. At the time of the fire, the other local railroads had already joined together for the construction of the Union Station on Main Street. The Cincinnati Southern had not joined the other railroads when they established their union and remained independent in its passenger depot operations. Swift action was required to rebuild the depot lost to fire. No time was lost, as reported in a September 1906 issue of the *Lexington Leader*:

> *The new Lexington station of the Cincinnati Southern Railway, the excavation for which is about completed, will be one of the handsomest kind in the South, and will be an attractive feature of Greater Lexington. It will be built of brick and stone and...especially attractive.*

Entered on the National Register of Historic Places in 1987, the Southern Railway Passenger Depot is described in its nomination form as "a massive, two-story, Georgian Revival style brick structure situated at a very visible point on a crest of a rise."

History has recognized three individuals as collaborators in the building's design: H. Herrington, whose identity and vitae remain a mystery; Paul Anderson, a notable professor of engineering for whom that University of Kentucky college is named; and Arthur Giannini, a significant architect in the region during the early twentieth century. Although it is not fully clear which of the three is responsible for the design of the depot, history is clear that Hendricks Brothers and Company, the premier local construction firm, was awarded the contract to build.

The design was grand. Those entering through the massive portico were certain to be impressed. On either side of the entrance, a pair of stone columns climbed two stories toward the heavens. A *porte cochère* ran the

western length of the depot; it offered passengers boarding and disembarking their trains some protection from the elements as they entered Lexington's Southern Railway Depot.

Two stone pillars, each of which was nineteen feet tall, supported the observation portico. The pillars were the "largest stone pillars ever erected with a building in Lexington," remarked the *Lexington Leader*. A grand project, indeed!

A prominent round room projected from the main space of the building. Although it eliminated any symmetry from the building's design, it did add a complementary feature that made the depot such a significant landmark and so pleasing to the eye.

THE PINNACLE AND DECLINE

Unlike the other passenger rail companies that served Lexington in the twentieth century, only the Cincinnati Southern Railroad utilized its own depot. The others utilized spur lines into downtown and had consolidated passenger rail at Union Station. By contrast, the Southern Railroad's main line went directly into Lexington and over Main Street, by way of a viaduct. It was for this reason that it was not feasible for Cincinnati Southern to participate in Union Station.

In 1930, sixteen passenger trains stopped at the Cincinnati Southern Depot daily. That same year, the railroad's main line through the city was upgraded to a double track greatly increasing capacity for the line. Rail travel was not all business; Sunday excursions allowed for leisure travel to Cincinnati or High Bridge for weekend relaxation, though these excursions were largely suspended during the world wars. Lines like the Queen & Crescent and the Royal Palm allowed travelers to reach exotic destinations like New Orleans and Miami, respectively. In 1932, "Mystery Excursions" began taking travelers to destinations unknown until their arrival; newspaper reports indicate that even the engineer and conductor were kept in the dark about the train's final destination.

But by 1970, passenger rail had all but ceased in Lexington. By 1981, the once-proud Southern Railway Depot had seen its glory masked and covered. Terrazzo floors were carpeted over. "The waiting rooms and dining rooms have been converted for freight storage. Marble walls have been painted over or paneled, the high ceilings covered with acoustical tiles," according to reports in the *Lexington Leader*.

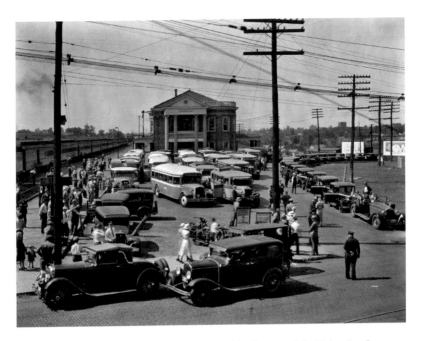

The busy Southern Railway Depot, circa 1932. *Courtesy of the University of Kentucky Libraries.*

The Southern Railway Depot as seen in the late 1970s, a few years after passenger service to the depot had ended. *Courtesy of Tom Rock.*

With no service to Lexington, it became difficult to sustain the cost of the grand old depot. In 1982, preservationists expressed their fears that the old landmark might be torn down. To its credit, the Southern Railway even offered the building to anyone who would pay for its removal to a different location. Unfortunately, there were no takers.

Demolition reprieves in 1983 allowed for tentative agreement between preservationists, rail buffs and the railroad. One proposal would have converted the old depot into a family entertainment complex with an upscale restaurant. Initially slated to open in 1986, financing and other complications kept delaying the project. The project was abandoned in 1990 in favor of a proposal to convert the old depot into commercial office space. But the proposal for adaptive reuse of the space wasn't to be. On May 5, 1991, "fire swept through Lexington's old Southern Railroad Depot early yesterday, gutting the structure and leaving the once-stately building strewn with charred wood and twisted metal," per an article in the *Lexington Herald-Leader*. The fire's cause was determined to be arson, and a seventeen-year-old boy was charged with the crime.

The fire was the final nail in the old depot's coffin. Before its demolition, the Southern Railway Depot had "the dubious distinction of being the last major railroad station standing" in the region. Today, little remains to note the import that this mode of transport once held.

6

JOYLAND PARK

In the midst of the Roaring Twenties, an amusement park and dance casino opened along Lexington's Paris Pike. Located approximately two miles from the city limits, Joyland Park featured parking for hundreds of vehicles; the abundant parking proved quite popular in the growing age of the automobile. It was also conveniently located along the interurban rail line between Lexington and Paris, as well as on a bus route. Though constructed over a number of years, the conveniently located park cost approximately $350,000 to build.

Frank Brandt and brothers John W. and F. Keller Sauer owned Joyland Park. Brandt was well known in Lexington as the owner of the popular Savoy Restaurant on West Main Street, just to the west of Limestone Street. In addition to being partners with Brandt, the Sauer brothers also managed the park. The property and amusements would be sold at auction in 1942. Garvice Kincaid was the winning bidder at the auction.

Half of the twenty-plus acres constituting Joyland Park were filled with promenades, roller coasters, a dance hall, a swimming pool, a train and more. Only half of the park's acreage was utilized by the attractions, which were added to throughout the years, but ten acres remained reserved for play and picnicking. It was a destination for those in Lexington and beyond!

With the immediate popularity of the bigger (and better and closer) Joyland Park, its chief competitor quickly fell into the lost annals of Lexington history. The Bluegrass Amusement Park was six miles out of Lexington along Versailles Road and, though popular, could not keep up with the newer Joyland Park, which was some four miles closer to town. Bluegrass

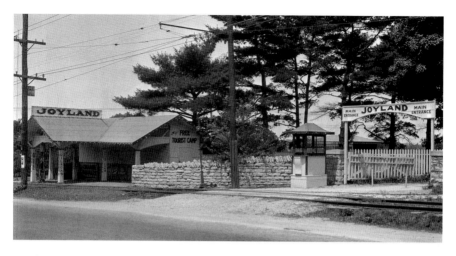

The entrance to Joyland Park along Paris Pike. *Courtesy of the University of Kentucky Libraries.*

Amusement Park did not open its gates in the summer of 1925, as it was clear that "Lexington is not large enough to support two amusement parks." Lexingtonians chose Joyland.

THE CITY'S FIRST SWIMMING POOL

Perhaps the most popular of the attractions at Joyland was the swimming pool that opened in 1928. At a cost of $90,000, the Joyland Park pool was considered the "South's Finest Pool." Well-maintained, the pool featured underwater illumination and could be entered through the large sand beach. It was an early version of the zero-entry pool.

The pool was the first public swimming pool in Fayette County and the region. Here, generations of central Kentuckian children learned to swim. The popular "I grew up in..." Facebook groups bare witness to this. References to Joyland Park for any of these local groups reveal an overwhelming number of recollections of those who learned to swim at the popular public pool.

Aside from being the first public pool in the county, the price of swimming lessons was perfect, even in an era when the country was suffering through the Great Depression. Parents monitored the expenditure of every penny, so the *Leader* (and after its merger with the *Herald*, the *Herald-Leader*) offered

free swimming lessons to children between the ages of ten and sixteen, making this rite of childhood available to all children in the region. It was an "opportunity to swim free of charge at the sanitary Joyland Park pool." The offering was made to the children of Fayette County and those from the surrounding counties. Each year, hundreds of boys and girls took advantage of the opportunity.

The sexes were divided during the *Herald-Leader*'s swimming lessons at Joyland Park. Typically, girls would be taught to swim during five daily sessions in a given week with the boys following with a similar arrangement the following week. The *Leader* first offered the free swim lessons to the region's youth in 1930 and continued the tradition for twenty-three years; the last account of the Learn-to-Swim course in the *Herald-Leader* was in the summer of 1953.

Divided, too, were the races. In fact, black children were not initially afforded the "opportunity to swim free of charge at the sanitary Joyland Park pool." The era of segregation in Lexington, however, still afforded young African Americans the opportunity to swim. Advertisements in the *Leader*'s "Colored Notes" section gave notice that the paper would provide "free swim classes" for children of color. These "separate but equal" swimming lessons were given at the pool at Douglass Park on Georgetown Street. Local historian Yvonne Giles recalls: "[my] mother made sure that we took advantage of the lessons every summer."

Although Joyland's pool received competition with the opening of the public (white) swimming pools at Castlewood Park in 1939 and Woodland Park in 1955, the tradition of swimming at the pool at Joyland Park remained strong. One popular feature at Joyland's pool was the islands of fixed concrete, which were similar to the floating docks popular in lakes. But there was fun beyond the swimming pool, too.

A PLACE OF AMUSEMENT

Along the midway at Joyland Park, visitors witnessed a variety of games of chance, vendors and other sorts of entertainment. In total, there were twenty-six vendors along the midway. One ride, the Pretzel, was described as "that funny, mysterious dark ride" that featured a miniature Cumberland Falls. Both the Pretzel and a miniature golf course were added to Joyland in time for the 1930 summer season.

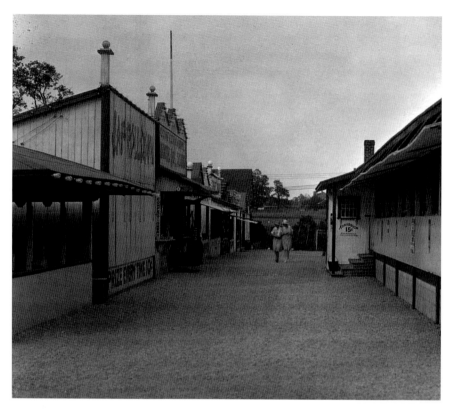

The midway at Joyland Park in Lexington, Kentucky. *Courtesy of the University of Kentucky Libraries.*

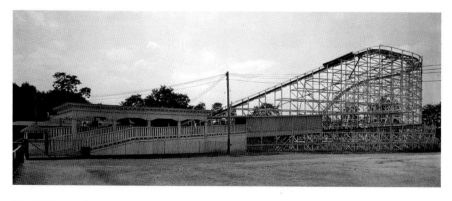

The Wildcat roller coaster at Joyland Park in Lexington, Kentucky. *Courtesy of the University of Kentucky Libraries.*

The history of the park's merry-go-round suggests that it was added to Joyland upon the closure of Bluegrass Amusement Park when the assets of the latter were sold. This is according to the records of the Philadelphia Toboggan Company (PTC), which built and designed the carousel. The melody emanating from that merry-go-round's organ attracted young and old alike, while the smells from the midway's food vendors tempted another of the senses. Other rides, like the tilt-a-whirl, the octopus and bump-um cars, all drew in visitors with the excitement of a county fair. But unlike those seasonal fairs, Joyland Park was available for more than a single week of the year.

Some schools would visit Joyland Park in the spring on field trips, while a number of summer vacation Bible schools concluded their sessions with a trip to the park on Paris Pike.

But perhaps the most well known of Joyland's amusements was the Wildcat. Like Joyland Park's carousel, the Wildcat was designed by the PTC. This wooden roller coaster opened in 1929. Twelve passengers could ride at any one time, two abreast, split equally among two cars with the three rows each. It is oft repeated that the name for the ride was to honor the University of Kentucky's mascot. This may be true, but it is also true that the Wildcat was a very common name for wooden roller coasters designed by the Philadelphia Toboggan Company.

Herbert P. Schmeck, the man who designed PTC's coasters, designed the Wildcat, along with nearly all other roller coasters (by PTC or its competitors) built in the 1920s. In fact, over eighty wooden roller coasters are credited to Schmeck. He and PTC truly had a corner on the market! It is worth noting, though frightening in retrospect, Schmeck had no engineering background but simply studied blueprints and employed his general construction knowledge in designing his roller coasters.

The other significant roller coaster at Joyland was a steel kiddie coaster that opened in 1950.

THE CASINO

One of the earliest offerings at Joyland was its casino. Although the name immediately conjures up a scene associated with Las Vegas, the Joyland Casino offered a different sort of casino. Although modern usage of the noun strictly refers to a place of gambling, the term has historically included

any civic place of gathering. And people certainly gathered at Joyland's casino! Nearly 1,600 people could be accommodated within the well-lit and well-appointed casino. There was, of course, some suggestion that gambling occurred at Joyland, though a 1950 verdict acquitted Joyland Park of permitting gambling on their premises. Instead, the facility provided a location for nightly dancing during the summer and was a desirable venue for social events throughout the year.

Joyland Park regularly found its way into listings of amusement parks that featured major bands, so that managers of the various musical acts might discover the venue. In time, Joyland Park became a premier site for musical entertainment.

Duke Ellington and his orchestra played in August 1937 and again in August 1951. Arte Shaw and his orchestra performed here in August 1938. Many of the era's great musical acts performed at Joyland Park with the sounds carrying throughout the park. High school and college students would travel from town to Joyland Park on dates to dance to the biggest performers of the day. Fraternal organizations often assembled at the casino. Corporate gatherings were often held at the Joyland Park picnic grounds. A Labor Day celebration in 1925 drew some twelve thousand people—an attendance figure that dwarfed the hundreds of Shriners, Freemasons, Veterans of Foreign Wars, Girl Scouts and others who occasioned on the grounds.

A fire ravaged and leveled the Joyland Park casino in 1946, causing some $100,000 in damage. The casino was rebuilt and remained a major success until its popularity finally waned. The amusement park closed in 1960. Another fire destroyed the old casino in the summer of 1965, with estimates of damage at around $200,000. The casino was not rebuilt.

In its place, a new subdivision, named Joyland, was constructed north of Interstate 75. Mary Todd Elementary School, as well as a bowling alley, also named Joyland, was built on the site of the old Joyland Park.

OLD KENTUCKY ASSOCIATION TRACK

Worldwide, the word Kentucky conjures up imagery of horse racing and of the Kentucky Derby. But even before Aristides raced across the finish line at the first Kentucky Derby in the inaugural year of Churchill Downs, the horse industry in Kentucky enjoyed a long history.

As Virginians poured into the Bluegrass and Lexington developed its reputation as the Athens of the West, the "sport of kings" descended upon the region. Horses, already raised as livestock for utilitarian purposes had, for centuries, been adaptable to pleasure racing. As the threat of Indian attacks subsided and time could be spent for luxury, the people of Lexington turned to the steed for entertainment.

EARLY RACING

As it turned out, racing along Main Street was not advisable. The work of a few faulty farriers may have resulted in some injury to racing spectators who came dangerously close to flying shoes! On October 21, 1793, the Trustees of Lexington issued the following statement that was published in the *Kentucky Gazette* and signed by John Bradford as chairman of the city's board of trustees:

> *The Trustees of the town of Lexington, feeling the dangers and inconveniences which are occasioned by the practice (but too common) of*

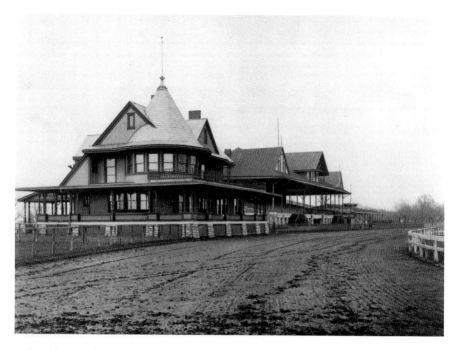

Above: The Kentucky Association, established in 1826, constructed this racetrack near Fifth and Race Streets in Lexington. When it closed in 1933, it was the oldest racetrack in the United States. *Courtesy of the University of Kentucky Libraries.*

Left: The intersection of Lexington's Race and Fifth Streets. Now part of the East End neighborhood, the intersection once was the entrance to the storied Kentucky Association racetrack. *Author's collection.*

racing through the streets of the inn and out lots of the town, and convinced that they are not invested with saficient [sic] authority to put a stop to such practices, recommend it to the people of the town, to call a public meeting, to consider of the means which ought to be adopted for applying a remedy to the growing evil.

It was resolved to move all racing activities to the Commons. Even at the Commons, both distance and course varied. It was noted in the *Kentucky Gazette* that races could extend as long as four miles. (By comparison, the Kentucky Derby is a mile and a quarter.) With races of varied lengths over varying paths, the need for consistency became essential.

To these ends, influential horsemen organized the Kentucky Jockey Club (later, the Lexington Jockey Club) in 1797 at the city's most important tavern, Postlethwait's. The jockey club established a new track in Lee's Wood, just west of town on land now part of the Lexington Cemetery. There, a one-mile circular grass course was built.

In 1826, a new organization was formed—the Kentucky Association for the Improvement of the Breeds of Stock—by some of the most influential people of the region. The Kentucky Association utilized the old grass track at Lee's Wood for two years before the Kentucky Association Track was opened in 1828.

The site selected for the Kentucky Association Track was along Fifth Street, to the east of Lexington. The cross street, Race Street, assumed its name after the track and remains as a vestige of the Kentucky Association Track's historic location. Ultimately, between 1828 and 1834, the Kentucky Association would acquire sixty-five acres of land on which the track and accompanying facilities would stand. Dr. Elisha Warfield almost exclusively selected the site.

THE FATHER OF THE KENTUCKY TURF

Warfield received his degree in medicine from Transylvania University. He then engaged in a successful medical practice before returning to his alma mater as its first professor of surgery and obstetrics. He was involved in the formation of both the Kentucky Jockey Club and the Kentucky Association. His role in the breeding and racing of horses, however, has resulted in his honorary title as the "Father of the Kentucky Turf." Warfield bred the great

stallion Lexington. After a successful racing career, Lexington retired to stud, where he would go on to sire yearlings for fourteen years, impacting generations of bloodlines.

Although the location selected by Warfield would eventually come to resemble our modern impressions of horse racing, the original track in 1828 was quite different. The track was described as "four miles wanting twenty two yards and rather a slow course to run over having two sharp hills" by the *American Turf Register and Sporting Magazine*. In other words, the initial Kentucky Association Track may have been even less desirable than the track at Lee's Woods.

CHITLIN' SWITCH: A MODEL RACE TRACK

By 1832, the Kentucky Association had remodeled its track after the Union Course in Queens, New York. Union Course was the first skinned, or dirt, track in racing and the Kentucky Association Track was the second. The Kentucky Association Track also adopted Union Course's then-unique inclusion of fencing around the racing surface. In addition to the one-mile track, a grandstand, a stable and other accessory buildings were also erected. It was quickly recognized as one of the finest horse racing venues in the nation.

As evidenced by its name, the Kentucky Association for the Improvement of the Breeds of Stock engaged not just in equine racing, but also in efforts to improve the quality of various breeds of livestock bred in central Kentucky. Thus, the association's sixty-five acres were also utilized to improve and promote these other breeds.

On September 17, 1833, the "first fair for exhibition of stock by Kentucky Association took place on Association Course," reported the *Lexington Observer & Reporter*. The popular fairs held on the grounds of the Kentucky Association also helped to reveal a less genteel side to the association's grounds.

The Kentucky Association Track's popular nickname was Chitlin' Switch. The source of the name is two-fold. A chitlin' is a small piece of deep-fried or boiled pig intestine, a popular snack in the region, which was particularly popular among jockeys, trainers and even some of the owners. The switch referred to the railroad spur on which visiting horses arrived at the track.

In January 1872, the members of the Kentucky Association approved significant renovations to the track and facilities. Significantly, the track was "made level and hollows filled and widened to 40 feet at head of stretch."

Additionally, the "old stands [were] replaced with [a] modern building," reported the *Lexington Press* later that spring. Although far removed from the four-mile course with two sharp hills mentioned in 1828, it seems surprising today that the areas around the track of 1832 were not truly made level for the facility's first forty years!

One of the finest and most popular races at the Kentucky Association Track was the Phoenix Stakes. The race was named after and sponsored by the Phoenix Hotel downtown. The race was known in various instances as the Brennan, the Chiles, the Phoenix, the Association, the Phoenix Hotel Stakes and the Phoenix Handicap. Irrespective of name, it was first run in 1831. Last run at the Kentucky Association Track in 1930, the tradition of the Phoenix Stakes was renewed at Keeneland in 1937, and it is now considered the oldest stakes race in the United States.

A Final Gallop for the Great Man o' War

One of the most storied horses in racing is Man o' War. Foaled in 1917, Man o' War was first owned by the Belmont family, for whom the Belmont Stakes is named. Man o' War trained in Maryland after being sold as a one-year-old to Samuel D. Riddle. At the time, Riddle did not care for Kentucky horse racing, and thus, Man o' War never raced within the Commonwealth. For this reason, Man o' War was not entered as a three-year-old in the Kentucky Derby. Winning twenty of his twenty-one career races, it is entirely possible that Man o' War would have taken the Triple Crown had he been entered in the Derby. In 1920, he won both the Preakness Stakes and the Belmont Stakes, the other two legs of the Triple Crown.

By the mid-1920s, Riddle must have changed his opinion of the Bluegrass State. He acquired the Faraway Farm and sent Man o' War there to stud. But before his retirement, Man o' War would circle a track once more. In 1920, Man o' War galloped around the Kentucky Association Track in a final, public farewell. It was his first (and last) time around a racetrack in Kentucky.

And what turned out to be Man o' War's own swan song was only an omen for what was coming for the old track at Fifth and Race Streets. It, too, would soon experience its own curtain call.

ECONOMIC HARDSHIP

Now over a century old, the Kentucky Association Track was showing signs of its age. Members of the Kentucky Association considered for several years how the future of horse racing in Lexington should proceed. Some years earlier, the Financial Panic of 1893 resulted in widespread distress to the markets, including the trading of horses. New foals were creating an oversupply of thoroughbreds, further devaluing the stock. It was an increasingly difficult investment to sustain. To reduce the oversupply, breeding operations were largely suspended. This effectively ended racing for a time because there was simply a lack of two- and three-year-olds to race.

In 1898, the Kentucky Association Track even closed for a few years. With the investment of a steel baron from Pittsburgh, Pennsylvania, named Sam Brown, the Kentucky Association Track was able to reopen. A feature of the track's revival under Brown was the introduction of another popular stakes race, the Blue Grass Stakes. First run on May 10, 1911, the Blue Grass Stakes would repeat eleven times at the Association Track, through 1926. And like the Phoenix Stakes, Keeneland renewed the tradition in 1937.

Four years after Black Tuesday and America's descent into the Great Depression, the Kentucky Association Track and accompanying facilities had fallen into a great state of disrepair. According to one account, the old track was in such a condition "that reclamation is highly impractical." Though it was not the first time the Kentucky Association shuttered following an economic collapse, it was the last. The track permanently closed its gates in 1933. At the time, it was the oldest track in the United States.

After the track closed, Lexington was without a horse racing venue for a few seasons until Keeneland opened its gates on Versailles Road in 1935.

URBAN REDEVELOPMENT

President Franklin Roosevelt's promise for a New Deal included a number of public works projects throughout the country. These projects simultaneously provided work for the unemployed and provided significant infrastructure upgrades in various areas. A report conducted in 1934 revealed that Lexington's "housing stock" was woefully deficient. So, the Public Works Administration

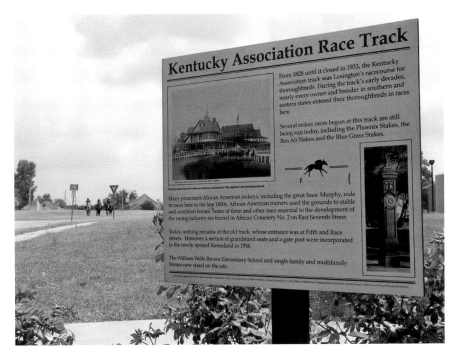

A small plaque near the William Wells Brown Elementary School in Lexington notes the racing history that once took place on the site. *Author's collection.*

built two housing projects adjacent to one another. A dominating feature of the two developments was the barrier that separated them.

Bluegrass Park contained 144 units and Aspendale contained 142 units when they opened on January 1, 1938. The former was for white residents and the latter was for residents of color. Separating the two projects from the beginning, according to a *Lexington Leader* article, was an "eight-foot wire mesh fence, topped with strands of barbed wire."

On their openings, both projects immediately filled. Over time, additional units were added to the projects. By the early 1950s, the original units of both Bluegrass Park and Aspendale were joined by the development of hundreds of additional public housing units. Constructed of redbrick, the barrack-style public housing units ultimately numbered 936.

For many years, these housing projects provided excellent, affordable housing for those who needed assistance in Lexington. Children had fond memories of growing up here, and those memories cannot be tarnished by what ultimately became of the Bluegrass-Aspendale area.

The area that had once been home to the country's oldest horse racing track turned into "stereotypical crime-plagued public housing stock that had declined into one of the least desirable residential spots in central Kentucky." Eventually, a mixture of federal, state and local dollars was utilized in the demolition of the old housing projects, and a massive revitalization of this area of Lexington's East End.

Today, the old barracks, streets, landscape and even the name of Bluegrass-Aspendale have dissipated into the recesses of Lexington's history. New neighborhoods with peculiarly suburban names have popped up on Lexington's East End: Grand Oaks, The Shropshire, Bridlewood and Equestrian View, to name a few. The neighborhoods now contain a more diverse cross-section of the population, and the landscaping is fitting of the rural and scenic monikers given to the new neighborhoods.

An elementary school and park now stand on the land once occupied by the old racetrack. The elementary school was named after William Wells Brown. Brown was born a slave in Lexington in 1814, but ultimately escaped to Ohio where he taught himself to read and became a freedman. He was a conductor on the Underground Railroad and a well-known author and lecturer.

A plaque on the site honors William Wells Brown and another acknowledges the former site of the Kentucky Association Track. Though "nothing remains of the old track," the plaque near the intersection of Fifth and Race Streets approximates the location of the entrance to this important early venue of horse racing history.

STOLL FIELD AND MCLEAN STADIUM

When it comes to college football, there is no greater tradition than the Southeastern Conference (SEC). But not all who pledge allegiance to the SEC know that its first conference football matchup was between powerhouses Kentucky and Sewanee. Though the Purple Tigers would leave the conference in 1940, they were one of the charter schools of the Southeastern Conference. That inaugural SEC football game was played in Lexington, Kentucky, at Stoll Field on September 30, 1933. Kentucky won the matchup by a final score of 7–0. The presence of the matchup at Stoll Field highlights the tradition of athletics in Lexington and at the University of Kentucky.

A BASKETBALL SCHOOL…AND A FOOTBALL SCHOOL

Of course, the University of Kentucky (UK) is inextricably linked to college basketball, and college basketball is inextricably linked to the University of Kentucky. UK's men's basketball team is often referred to as the "greatest tradition in college basketball." But at one time, the UK Wildcats were competitive on both the hardwood and the gridiron.

Two of the greatest coaches in college athletics, Adolph Rupp and Paul "Bear" Bryant, had overlapping tenures as head coaches at the University of Kentucky. Rupp led the basketball program while Bryant oversaw the

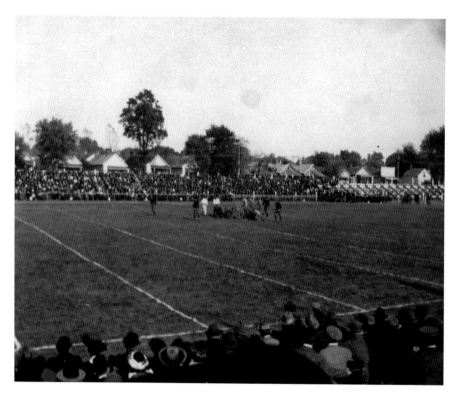

On October 14, 1916, Vanderbilt soundly defeated Kentucky at Stoll Field by a score of 45–0. It was Kentucky's only loss of the season. *Courtesy of the University of Kentucky Libraries.*

football team. Both coaches were well respected, but football would not achieve the level of prominence basketball had at UK. An oft-repeated joke by Bryant found its way into an Oklahoma newspaper and, thus, into the history books. The two coaches attended a banquet at which they each received gifts. "Adolph Rupp was presented with a big four-door Cadillac. All I got was a cigarette lighter," rang out Bryant's punch line. Though football has had its success at the University of Kentucky, basketball has always been king.

Rupp coached basketball first at Alumni Gym and then at Memorial Coliseum, which was nicknamed "the House that Rupp Built." The basketball team left Memorial Coliseum in the 1980s for a facility formally named after the coach who had created a dynasty on the hardwood in Lexington: Rupp Arena.

Bryant left UK following the 1952–53 season for Texas A&M. He remained there a few seasons before creating his dynasty in Tuscaloosa at the

University of Alabama. Since then, Kentucky's football program has had a number of coaches, first on the sidelines of McLean Stadium and, after its demolition, Commonwealth Stadium.

But some of the greatest moments in Kentucky football occurred on hallowed land known also as Stoll Field and within the McLean Stadium, which once stood proudly there.

PRESIDENT PATTERSON'S PASTURE

In 1865, James K. Patterson assumed a professorship at the Agricultural and Mechanical College of Kentucky. At that time, and through 1878, the college was a part of the larger Kentucky University.

Kentucky University, like many institutions of higher learning of the day, was founded in affiliation with a religious organization. Its College of the Bible evolved into a significant seminary for the Christian Church (Disciples of Christ). In 1878, theological differences caused the two schools to separate.

Kentucky University retained the campus in the Woodlands, but leased it to the State A&M College. The Woodlands campus was to the immediate east of Clay Avenue and would today be recognized as Woodland Park.

The cost of renting its campus, along with plummeting tuition numbers, sparked great concern in Frankfort for the face of the Commonwealth's only public college. This was a big moment for the future of both Lexington and for what would become the University of Kentucky.

A bidding war began among a number of Kentucky communities vying to be the home of the only state college in Kentucky. Bowling Green made a strong bid and nearly stripped Lexington of its opportunity to be the home of two major institutions of learning—UK and Transylvania University.

But the City of Lexington finally offered $30,000, plus its fifty-two-acre city park on the southern edge of town, to serve as the home of the state college. Fayette County added $20,000 to the effort to entice the legislature in Frankfort to keep the state college in Lexington. In 1880, they made Lexington the permanent home of the state college.

For a number of years still, the school largely emphasized agricultural and mechanical studies. President Patterson continually added more and more liberal arts to the curricula. The shift from agricultural and mechanical studies to liberal arts was recognized

by the state legislature in 1908, and the school was re-chartered as State University: Lexington, Kentucky. And in 1916, the University of Kentucky moniker was formally adopted.

While the school was an agricultural institution, cows freely grazed upon President Patterson's pastures, which were nestled along the creek that ran through the grounds.

AN AMERICAN SPORT

Even before the school had formally become the University of Kentucky, a sport had gained popularity on college campuses. American football began as a variation of the rules of an older sport: rugby. In 1869, Rutgers and Princeton engaged in what has been described as the first recorded intercollegiate football game.

Rules of the sport slowly took shape over the following decades, and the popularity of the game spread from its eastern beginnings across the country. In 1881, the sport reached the Commonwealth as State College first fielded a football team in that year. In its premiere game, State College defeated Kentucky University (another earlier name for Transylvania University) by a score of $7\frac{1}{4}$–1. How scores, and particularly quarter points, were determined in those early matchups remains a mystery. This strange matchup that resulted in a quarter point scored can also be described as the first football game south of the Mason-Dixon Line.

The game bears great significance, however, not just on the history of Kentucky's football program, but also on the history of football across the south. Of all the programs that would eventually come together to form the Southeastern Conference, Kentucky's team was the first to organize.

The 1881 season came to an end after three games, with State College earning only a 1–2 record. Play wouldn't resume for nine seasons, when on April 10, 1891, State College defeated Georgetown College by a mark of 8–2. The following year, Professor A.M. Miller became the first known head coach during an era when college professors regularly coached the school's team for a year or two before handing the reins over to a colleague. The same was true on the hardwood.

Each of the home games during these early seasons was played on President Patterson's old pasture grounds. One season played here should not be omitted from any story of either Stoll Field or of Kentucky football.

The team fielded in 1898 went "undefeated, untied, and unsecured upon." Known as the Immortals, this squad is the only Kentucky team to ever hold such a record.

A FITTING COLOSSUS

By the autumn of 1910, it was clear that football would need a permanent fixture on the college campus. Basketball was then played in Buell Armory's gymnasium, and the old grassy pasture was unfit for the grand sport of football. The *Lexington Leader* reported in November of that year that alumni of State University were launching an initiative "that has long been needed," which was "the erection of a stadium on Stoll Field where all the athletic contests take place."

It wasn't quite time yet. Characterized in the annual *K Book* distributed to students, the location of Stoll Field was the "extreme N.E. corner of the campus." Given the university's expansion during the twentieth and twenty-first centuries, it is difficult for the modern reader to consider the corner of Rose Street and what was then called Winslow Street, now the Avenue of Champions, to be an "extreme" corner of the college campus.

Even before a stadium was erected, the field of play had its name (albeit, unofficially). The *Kentucky Kernel*, the school's student-run newspaper, reported that the name Stoll Field was "given to the playground of the Wildcats at a meeting of the University Athletic Committee on October 7, 1898, and the name has stuck ever since, altho [sic] there has been no formal dedication in honor of the donor."

In 1915, earth began to move to enlarge Stoll Field, with the extension being toward Limestone Street, two hundred feet. The need for moving four thousand cubic yards of soil was precipitated by the desire to have separate fields for football and baseball. Over the summer of 1915, bleachers were added to the site. The facility could now properly be known as a football field, and the site was formally enshrined as Stoll Field.

The field was named after Richard C. Stoll, an alumnus of the university, a board trustee and a benefactor of the university. It was Stoll who is credited with the blue used in Kentucky's colors of blue and white. Originally selecting blue and yellow to be their colors, students were uncertain as to which shade of blue should be utilized when preparing for the game against Centre in 1891. Stoll held up his necktie, and the students adopted that very hue. The

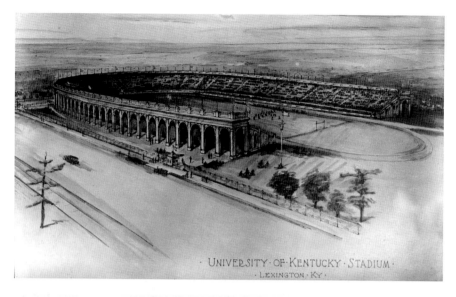

UNIVERSITY·OF·KENTUCKY·STADIUM·
·LEXINGTON·KY·

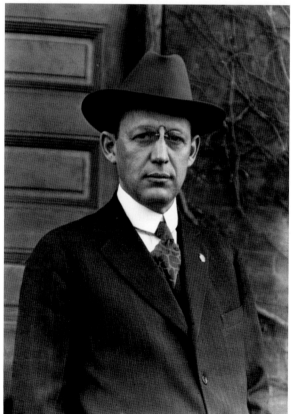

Above: A rendering of the proposed stadium for Stoll Field, circa 1920, along Winslow Street (now the Avenue of Champions). *Courtesy of the University of Kentucky Libraries.*

Left: Judge Richard C. Stoll, for whom Stoll Field was named. Once a member of UK's football squad, Stoll was later a benefactor for his alma mater. *Courtesy of the University of Kentucky Libraries.*

following year, the folly of blue and yellow was realized and the university officially adopted its colors as blue and white.

Stoll also played for the football team for four seasons, beginning that first full season of play (if one excludes the three contests in 1881) in 1891. Stoll was a member of the school's track team, as well as a manager of the baseball program. According to the *Kentucky Kernel*, a plaque honoring Stoll was placed in 1916 on the "new concrete box from which the President of the University and his guests will witness future battles on Stoll Field."

Though the field was named after Stoll, there still remained no grand stadium around the field of play as had been proposed earlier in the decade. In 1920, the *Lexington Herald* finally proclaimed the exciting news: "concrete stadium planned for Stoll Field. Plans being drawn." Plans developed for a twenty-four-thousand-seat facility on the site where President Patterson's cows once grazed. The 1925 *Kentuckian* yearbook suggested that, when completed, the stadium "will take the form of a huge horseshoe, opening at the west end, with the bow at the east end." The horseshoe would be comprised of sixteen sections, though not all would be built at once, but rather in phases as funds permitted.

As with many buildings constructed on the university's campus, the stadium was designed by one of the school's own: Professor D.V. Terrill both designed the stadium and served as resident engineer for the project. The plans were drawn and surveys conducted by seniors from the college of engineering. For construction, the local Louis des Cognets Company was awarded the bid to erect the stadium.

The home opener of the 1924 season saw a UK victory over Louisville, but those attending the game were only able to see it from the half-completed bleachers. It wasn't until the fifth home game of the season that the completed stadium would enjoy its formal opening. On November 1, 1924, the stadium opened with much fanfare to a significant crowd. Unfortunately, the Wildcats opened the facility with a loss to Centre College. But the stadium that opened in November 1924 still wasn't the great sixteen-section horseshoe planned. Only ten thousand seats were constructed, spanning six seating sections at the time; the cost to build this portion of the stadium was $137,000. As originally suggested, completion of the stadium would have to wait until sufficient funds became available.

Within a few years, however, the Great Depression would hamper the university's efforts to construct new facilities. Although athletic facilities were not the first priority, certain events did prompt the erection of additional seating. In 1930, a plan was made to erect permanent wooden seats at the ends of the concrete stands, to double the seating in what had only

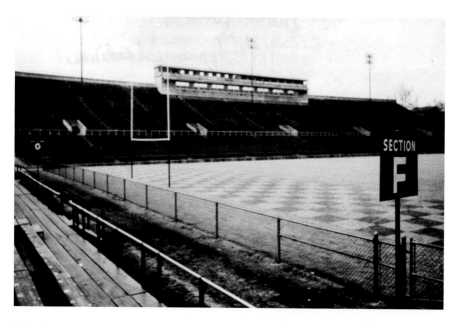

Bleachers were added to McLean Stadium prior to the Alabama contest in 1930, which saw a record attendance of twenty thousand. *Courtesy of the University of Kentucky Libraries.*

materialized to be a ten-thousand-seat facility. These expansion plans were modified in favor of six thousand bleacher seats. The additional seating was in anticipation of that year's matchup with the University of Alabama. The game, held on November 1, 1930, was hugely significant because the National Broadcasting Corporation distributed the game over the radio to households near and far. It was the first such game broadcast from Lexington. The twenty thousand attending represented the largest game ever in Lexington, though they witnessed the defeat of the Wildcats by the Crimson Tide, 19–0.

Following World War II, an additional four concrete sections were added to the stadium bringing total permanent capacity to approximately twenty thousand.

A TRIBUTE TO A FALLEN PLAYER

In the autumn of 1923, the Wildcats encountered a 4-3-2 record. "Brilliant flashes of play" were met with less stellar moments in a season that was summed up in the university's yearbook as "not disastrous."

Price Innes McLean

UK center Price James McLean (1901–1923) died after injuries sustained while playing in a football game against Cincinnati. UK's stadium was named after McLean the following year. *Courtesy of the University of Kentucky Libraries.*

Yet disaster did strike. During the second game of the season, the Wildcats met the Cincinnati Bearcats in Ohio. Price McLean, a twenty-two-year-old engineering student played center for the Wildcats. During the fourth quarter, he suffered a head injury with an almost certain concussion. The injury went untreated, and McLean shook it off before reentering the game. The day after the loss to Cincinnati, McLean passed away from the injuries he had sustained on the field.

The *Kentuckian* yearbook summed up Price McLean in glowing terms for his qualities not just as a player, but also as a human being:

The Blue Grass has had her favorite sons, whose names resound on the lips of countless Kentuckians, but none will ever hold the place that Price McLean occupies in the hearts of his comrades. A man indeed, with inexpressible good qualities that made his fellow students his chums and perpetuated his memory when death claimed him. It is saying the least when we say that he played the game of life as he fought on the gridiron—bravely, truly, and cleanly. He gave his all to his Alma Mater, and died as he had lived—a man.

On November 1, 1924, the six final sections of the stadium were opened, and the complex was named after the fallen athlete: McLean Stadium. The naming was at the suggestion of a number of students, though some administrators felt that the name of Stoll should be the exclusive name over all of the facility. Ultimately, it was settled that the stadium would bare McLean's name while the name of the old friend and benefactor of the university, Stoll, would remain the namesake of the field itself.

A NATIONAL CHAMPIONSHIP OR TWO

The 1950–51 academic year was arguably the greatest in athletics at the University of Kentucky. The familiar part of the story is tied, of course, to basketball. It was in the spring of 1951 that the Kentucky Wildcats defeated the Wildcats of Kansas State in Minneapolis to bring home to Lexington a third NCAA basketball tournament title after a 32-2 season.

Less known, however, is the accomplishment of the university's football squad during the autumn of 1951. At the end of the regular season games, the Wildcats had a record of 10-1. The Wildcats were destined for New Orleans with a spot in the Sugar Bowl. In those days, the national champion—by virtue of media rankings—was determined before the bowl season, and the nod was given to the Oklahoma Sooners.

But on New Year's Day in 1951, the Kentucky Wildcats defeated the number-one ranked Oklahoma Sooners, clinching a victory in the Sugar Bowl. Because the media had already completed the rankings for the season, the upset was not considered in choosing a national champion. Decades later, sports statistician Jeff Sagarin computed the rankings of historic football squads, inclusive of the bowl records. Sagarin's algorithms selected the Wildcats as national champions for the 1950–51 football season! Hindsight really is 20/20.

In either event, there is no doubt that it would have been an exciting time on campus. Coaches Adolph Rupp and Bear Bryant both earned well-deserved welcomes in Lexington as they brought significant trophies home to the University of Kentucky.

FOR YOUR HALFTIME PLEASURE: THE UNIVERSITY OF KENTUCKY MARCHING BAND

As is still the tradition at universities and colleges across the nation, the University of Kentucky marching band performs at midfield during halftime of home football games. Though contemporary music has entered the repertoire of today's marching bands, those listening to the band marching on Stoll Field would have been more accustomed to the sounds of patriotism, Sousa and other traditional sounds.

With military precision, the members of the marching band kept both key and step as they created living text upon the field. Common formations included the block letters "KY," the words "Kentucky" or "Hello" and the letters "UK."

Another formation that was popular among those watching the performance at McLean Stadium was "DIXIE" in block letter. This formation was accompanied by the southern anthem of the same name. Though the song was a favorite of Abraham Lincoln's, many linked the music to both slavery and discrimination. Following student protests over the use of the song and formation, both were dropped from the UK marching band's repertoire.

MORE THAN FOOTBALL

In 1938, the *Lexington Leader* ran a column that described Stoll Field as a "Historic Rally Place" noting that the land had been "the scene of important gatherings in the past. It was the scene of barbecues and political orations. It was the Fair Ground. But it was also the scene of war where armies mobilized. The stadium itself is a memorial."

For their military training, boys arrived at Union Station from across the Commonwealth. Then they would go the short distance to the historic Stoll

Field where training would commence. From Stoll, the young men would soon serve their country in war. Yet Stoll Field was also a site for celebration.

Nearly five months before the December 7, 1941 raid on Pearl Harbor, fireworks were launched from Stoll Field in celebration of America's independence, during Fourth of July festivities. It was the first time Stoll Field served as the host of the city's celebration, and it occurred almost by accident. A week prior to Independence Day, a golf club cancelled its plans for a fireworks display and donated its explosives to the city for use at Stoll. Under the theme "Rededication to Americanism," Lexingtonians enjoyed the fireworks launched from within the stadium. The venue would be one of a handful in Lexington that would continue the tradition of launching skyward fireworks on Independence Day.

A Billy Graham revival held at Memorial Coliseum in 1971 found Stoll Field filled with overflow seating across Avenue of Champions from the main venue. Loudspeakers were set up to project the evangelist's voice to those in McLean Stadium.

Saying Goodbye

On Veterans Day 1972, the headline in the *Herald Leader* read "Goodbye, McLean. Wildcats meet Vanderbilt in Stadium Farewell." And with the conclusion of that game, the football stadium and field that had launched Kentucky's program, had witnessed both the first football game in the American South and also the first game in the Southeastern Conference would be no more. For a short time, history-minded fans sought to bring to the newly named Commonwealth Stadium the traditional name for their storied field: Stoll. This, however, was a futile bid as the school already struggled with confusion over dueling monikers at Stoll Field/McLean Stadium. The field at Commonwealth Stadium was unnamed until decades later, when the sod in Commonwealth Stadium would be named for longtime athletics director C.M. Newton.

Lexington artist Pan O'Nan had the following reaction when she learned that the stadium was to be razed: "I realized how much daily pleasure had been derived from McLean Stadium's lines, ivy, and general sense of monumental solidness—permanence. This was to be no more."

With all additions in place, the final capacity of McLean Stadium was thirty-seven thousand. But it just could not compete with the fifty-seven-thousand-person capacity of Commonwealth Stadium. A final

Fourth of July fireworks display was launched over Stoll Field in 1973.

By the end of the decade, the Singletary Center for the Arts had opened on the site once occupied by the stadium. A small patch of grass remains as a practice area for the marching band, though the green space remains under threat from campus development. In that green space stands a marker that honors the historic legacies of both McLean Stadium and Stoll Field.

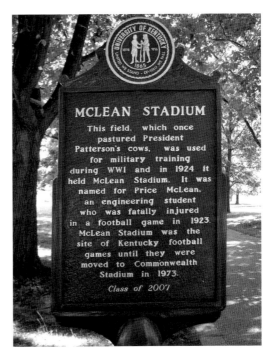

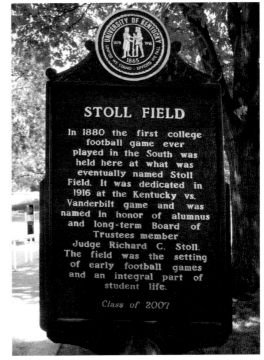

Top: A historic marker honoring McLean Stadium located on UK's campus. *Author's collection.*

Right: A historic marker honoring Stoll Field located on UK's campus. *Author's collection.*

9

LOST CAMPUS

A criterion for successful physical planning is the preservation for future generations of the significant existing facilities that best express the heritage of the campus.
—University of Kentucky Board of Trustees, March 2001

L ike colleges and universities across America, a significant number of structures at the University of Kentucky have been demolished since the school was first located on the grounds of the old city park. Evolutions in the school's mission and changes to student and curricular demands have necessitated a great number of changes.

One of the oldest buildings on UK's campus is Maxwell Place, which serves as the home of the president of the University of Kentucky. Maxwell Place predates the university's presence on the site. The home was named for the adjacent Maxwell Springs, about which Henry Clay once remarked, "no man can call himself a gentleman of Kentucky until he has watered his horse at Maxwell Springs." Built in 1872 by Dennis Mulligan, as a wedding gift for his son, James Hillary Mulligan, the family sold the residence (along with sixteen acres) to the university in 1916 for $40,000.

The second oldest building on campus is today known as the Main Building, though it has at varying points been called the College Building or the Administration Building. Originally, it housed all offices, classrooms and school facilities. It could nearly be included as a chapter in this book, for a fire in May 2001 gutted the structure, but the university's board of trustees voted to restore the storied piece of the school's history.

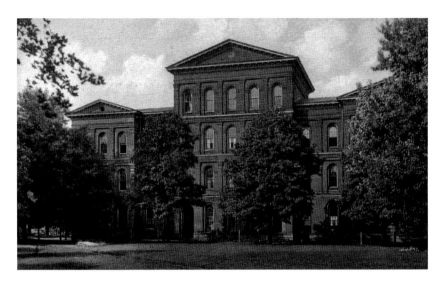

A postcard depicting the old Whitehall Dormitory on the campus of the University of Kentucky. Built in 1882, it was demolished in 1967. *Courtesy of LexHistory.*

Two months prior to that fire, the university adopted guidelines for the preservation of a number of historic buildings "that best express the heritage of this great campus." The list of buildings included Maxwell Place, the Main Building and many other important structures constructed between 1872 and 1950.

WHITE HALL DORMITORY

While the Main Building originally housed all classroom space, White Hall served as the original dormitory at State College. Both were dedicated on February 15, 1882. The earliest residents of White Hall paid five dollars per annum for the use of one of the ninety unfurnished rooms.

Originally, however, the old dormitory was not known as White Hall but simply as the Old Dormitory. In fact, the moniker was not added until the building was remodeled into classrooms in 1919. On the suggestion of UK president Frank L. McVey, the university's trustees honored one-time acting university president and mathematics professor James G. White by naming the Old Dormitory after him. At that time, it also became the home of the old College of Commerce.

The Patterson Office Tower and the White Hall Classroom Building sit on the site once occupied by President Patterson's home, the old White Hall Dormitory and the old Carnegie Library. *Author's collection.*

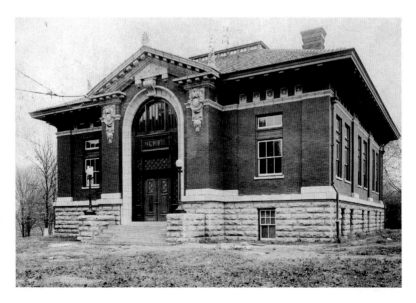

One of two Carnegie Libraries in Lexington and one of only sixteen in the Commonwealth, the Carnegie Library on UK's campus was a "shrine to literature." *Courtesy of the Historic American Buildings Survey (Library of Congress).*

In 1952, UK president Herman L. Donovan advised the university's board of trustees of the "deplorable condition" of White Hall, suggesting that "this building is a disgrace to any modern University and it should have been abandoned long ago." It was one of several facility upgrades listed by President Donovan as being in desperate need of improvement.

In 1963, a new Commerce Building (the present-day Gatton College of Business and Economics) was constructed, leaving behind the old White Hall and the question of what should be done with one of the oldest structures on campus.

The answer came in 1966, when the board of trustees received the first model for the construction of a new classroom building and office tower. The local architecture firm of Brock, Johnson and Romanowitz was retained to design a complex that would be located on the site of White Hall. In April of the following year, White Hall was demolished in favor of these two new structures. A number of the handmade bricks from the old White Hall were incorporated, both as pavers for the pavilion outside the new classroom building and office tower, as well as for a new base for the statue of the university's first president, James K. Patterson.

Another 1882 brick structure that had served as the campus's first president's home was demolished as part of this construction project. That building, the Patterson Home, was razed in March 1967, and its bricks, too, help support the statue of President Patterson.

On December 9, 1969, UK's board of trustees met for the first time in the conference room atop the newly constructed nineteen-story office tower. At the time, the tower and complex were referred to as the Classroom Office Tower Complex. History, however, was honored the following spring when the recommendation was made to the board that the "Complex should carry the names of the buildings that were razed for this new facility and which carried the names of these distinguished gentlemen." The resolution carried that the new classroom building would bear White's name; it is the White Hall Classroom Building. And the Patterson Office Tower is now a landmark visible in many parts of Lexington.

THE CARNEGIE LIBRARY

Steel magnate Andrew Carnegie proclaimed in his *Gospel of Wealth* the belief that wealth ought to be used to improve society. After selling his steel company to J.P. Morgan in 1901, he turned toward philanthropy. A great focus of his efforts was to construct public libraries throughout the English-

speaking world. Ultimately, 1,689 Carnegie Libraries were erected in the United States, twenty-seven of which stood within Kentucky.

In Lexington, the city's public Carnegie Library was built in 1906 and remains standing today in Gratz Park, though the library relocated from the site in 1987, and the Carnegie Center for Literacy and Learning occupies the century-old structure that marks the southern edge of Gratz Park. Another Carnegie Library was built on the State College campus in Lexington. The 1911 *Kentuckian* noted that Carnegie maintained a "well-established custom of never endowing two similar institutions in the same city." According to the yearbook, it was "the magnetic personality and the Scotch sagacity of Dr. Patterson [which] conspired to induce the noted benefactor to depart from his usual plans and to honor us with the princely gift." This suggestion, however, seems overstated given that greater Louisville counts some nine Carnegie Libraries.

In early April 1905, Patterson began correspondence with Carnegie (or more accurately, Carnegie's private secretary, James Bertram). Required paperwork was completed and additional correspondence ensued before Patterson proceeded with a direct and personal appeal by traveling to New York. Patterson obtained an audience with Bertram, as Carnegie was not in New York State at the time.

It was at his meeting with Bertram that Patterson seemed to learn of Carnegie's stipulation: "that an amount equivalent to the sum given by [Carnegie] should be raised by the corporation to whom the library was to be given," thus, ensuring that the Carnegie Libraries could be properly maintained. Patterson believed this to be an "insurmountable obstacle" to the plan, but was able to negotiate an alternative: "that the governing board would guarantee an annual sum equivalent to ten per cent of his [Carnegie's] proposed benefaction for the maintenance of the proposed library."

Both the board of trustees and Carnegie assented to the terms, and then Carnegie became the benefactor to the State College of Kentucky in the sum of $20,000, while an annual pledge of $2,000 from the university was made for building maintenance.

Work commenced in the spring of 1907, with the construction contract being awarded to the Hendricks Brothers and Company. The library was dedicated in 1909 "with appropriate exercises" according to the *Lexington Leader*.

The 1920–21 *Catalogue of the University of Kentucky* later described the library: "This building is the gift of Andrew Carnegie. It is located on the court between the Administration Building and the ex-President's home, is fifty-six feet square, two-stories high, including the tall basement of range-ashlar, is built of pressed brick, and trimmed with terra cotta."

The 1911 *Kentuckian* set forth this description: "Within the frescoed walls of this shrine of literature is contained the record of all that man has done upon the earth. All that man has thought, all that man has felt—*all* is held bound between the covers of the books which line the walls of this building." The *Catalogue* further identified the library as having 28,197 volumes between both the general library and department collections.

The first librarian at the school was Margaret I. King, who also served as Patterson's stenographer. Another library was constructed on campus in 1931, and that library was named for King in 1948. Today, the King Library houses the university's special collections. The old Carnegie Library was, like White Hall and the Patterson Home, demolished in favor of the Patterson Office Tower and the new White Hall Classroom Building.

THE LEGACY OF ERNST JOHNSON

As noted above, UK president Herman L. Donovan observed in 1952 that a number of campus facilities were in "deplorable conditions." He also recognized the demands of the growing institution that required new space for residential life, classrooms and research facilities. His report to the board of trustees precipitated the university's most significant period of physical growth.

During the 1960s, nearly thirty buildings would be constructed on the campus of the University of Kentucky. It was a booming time, literally, at UK. In the design of many of these new structures, the university turned to a familiar face: Ernst Johnson.

In 1911, Ernst Johnson was born in Ashtabula, Ohio, to the wife of a Swedish bricklayer. Johnson was raised around bricks in an era when craftsmanship meant excellence. Never a particularly strong student, Johnson still managed to go to college at a school near Cleveland before a combination of passion and ambition prompted his enrollment at Yale University. There, Johnson received his undergraduate degree in architecture as well as a master's degree in fine arts. He was brought to UK at the age of twenty-four after a classmate, William Brock, recommended his hire to UK president Frank McVey as a professor of architectural engineering.

As the nation continued to endure the harsh realities of the Great Depression, McVey needed to grow the campus while maintaining costs. To accomplish this, he utilized faculty in designing the new campus buildings. During his tenure as a professor, Johnson worked on many

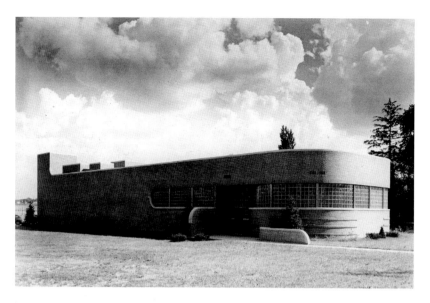

In 1941, the Wenner-Gren Aeronautical Research Laboratory's location seemed rural. In the ensuing decades, UK's campus would grow up all around the small laboratory. Ultimately, Wenner-Gren was demolished in 2014. *Courtesy of the University of Kentucky Libraries.*

The entrance to the Wenner-Gren Aeronautical Research Laboratory in the spring of 2014. The building was demolished later in the year. *Author's collection.*

campus buildings including Funkhouser Building, the original Student Union and Lafferty Hall. Each of these buildings remains standing. The same necessity and practicality that prompted McVey to utilize faculty guided Johnson in his designs.

Local architect Sarah Tate remarked in 1989 that Johnson's buildings "constitute a living museum of one of the more interesting periods of architecture in this century...[and] give us a record of that time, after the Great Depression and the World Wars when we, in America, had to adjust to doing more with less."

Columnist Jaci Carfango expressed a similar sentiment in 2014: Johnson "had exceptional talent and the benefit of an excellent education. But he also had the experience of laying brick with his own hands and the confidence to design a new type of building, one that didn't rely on echoes of the past but that fit the place, the use, the budget and the materials."

Though Johnson left his professorship at the university in 1945 to start his own architecture firm in Lexington, he would remain a presence at UK, as his firm was regularly hired during the post–World War II years to design the expanding campus. Some of the notable buildings designed by firms in which Johnson was a principal include Memorial Coliseum, the Peterson Service Building, the Fine Arts Building and the Patterson Office Tower/White Hall Classroom Building Complex.

Two notable buildings bearing the mark of Ernst Johnson that have been recently demolished are the Wenner-Gren Aeronautical Research Laboratory and the Holmes Hall dormitory.

WENNER-GREN

In 1940, the University of Kentucky received $150,000 for the purpose of constructing an aeronautical research laboratory from Axel Wenner-Gren, a Swede whose fortune had been made first in the design of the Electrolux vacuum cleaner.

At the time of its construction, America stood on the precipice of World War II, and the need for advanced aeronautical research was at its peak. Although many universities developed aeronautical schools during the era, UK's focus was strictly on the engine component itself. A reliably built American engine would provide dominance in the skies for America and her allies, courtesy of the "degree of mechanical perfection inherent in [American] machines," according to *Kentucky Engineer*.

One can only imagine the noise generated in the constant testing of an airplane engine. To accommodate the unique research that would occur within its walls, Wenner-Gren was constructed to mitigate this extreme sound. Thick concrete walls, ceilings and floors restricted sound waves from escaping the observation rooms.

In an interview with *Kentucky Engineer*, the building's architect (Johnson) noted the importance of steel in the construction of the building and how it allowed for both utility and beauty:

> *The steel beams have been hidden by a curtain wall of brick, but behind those curving walls, there is a framework of steel columns and beams which form the skeleton of the building. They do the actual work of support, while the brick walls and the glass block panels merely enclose the space.*

Johnson was referencing the notable west wall of the structure that, with its curved façade, created much interest. The same magazine offered an examination of this structural design that, in itself, offers a glimpse of the building's beauty:

> *A band of glass block six feet high runs continuously around the exterior walls of the west portion of the building, except the door openings, and is anchored between the flanges of steel columns that are exposed for the height of the band. The west wall corners are rounded to a 16'—2½"radius curve and the lintels supporting the brickwork are curved accordingly.*

By combining both form and function, Johnson was able to exemplify the very best of Streamline Moderne architectural design in Wenner-Gren. But in the late summer of 2014, Wenner-Gren was demolished as the University of Kentucky again found a need to alter its physical plant. The Blue Grass Trust for Historic Preservation composed an obituary for the lost landmark:

> *Designed by renowned architect Ernst Johnson, the Wenner-Gren Aeronautical Research Laboratory was an architectural marvel when it was completed in 1940. Streamline Moderne in style, the building had the look of an airplane, representative of the ground-breaking work that was done there, including designing jet engines and preparing America's first astronauts: chimpanzees. Lacking an appreciation for state, local, and national history, the University of Kentucky has chosen to demolish this architectural and historic gem.*

Holmes Hall as it appeared a few months prior to demolition in 2014. The building, with its unique canopied walk, was once a landmark at its prominent location at the intersection of Limestone Street and the Avenue of Champions. *Author's collection.*

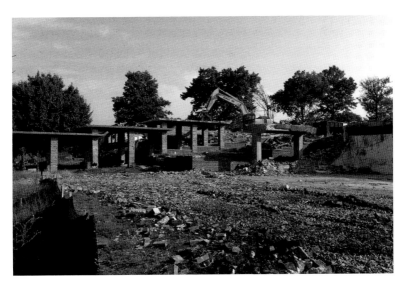

The unique canopied walk was nearly all that remained during the August 2014 demolition of Holmes Hall, but it too succumbed. *Author's collection.*

HOLMES HALL

Of all the buildings demolished at the University of Kentucky since 2010, the loss of Holmes Hall may be one of the most devastating. The structure stood at such a prominent location: the northeast corner of South Limestone and the Avenue of Champions (formerly known as Winslow Street). From its seat, Holmes Hall provided a welcome to the downtown area for those traveling into Lexington along U.S. Highway 27. Future generations won't witness the stone and brick dormitory that admitted sojourners into Lexington from the late 1950s until 2014.

Also designed by Ernst Johnson, Holmes Hall was named for the first dean of women at UK, Sarah B. Holmes. The structure largely consisted of three parts: a four-story brick dormitory not dissimilar to many other dormitories on campus, an interesting one-story brown stone appendage that wrapped the building's frontage along Avenue of Champions as well as part of its eastern façade (the same stone was smartly used around each of the entrances) and the final part of Holmes Hall that truly set it apart.

The stepped canopy rises from the Avenue of Champions on the southeastern side of Holmes Hall. Stone columns held up each step of the multi-level canopy, with each level constructed of seamless concrete. Low-rising brick walls connected the columns and provided a gathering place for generations of Wildcats who lived in, or visited, the dormitory.

From beneath the canopy, the covered walkway appeared as a portal to another world. And from above, the canopy gave the impression of a multi-step waterfall. Its beauty was such that it could have easily been part of Frank Lloyd Wright's Falling Water. It was a visible portal into the heart of Lexington until it was felled in the late summer of 2014.

Like the city in which it sits, the campus of the University of Kentucky is itself a growing and living organism. Each of the changes over the course of UK's 150-year history has resulted in a change to the needed physical layout of the campus. Sometimes, a remodeling of a building suffices, while other times, the university has turned toward demolition. The buildings mentioned in this chapter are only a handful of the many storied structures that once graced the campus of the University of Kentucky with their presence.

GREEN HILLS MANSION

The four Corinthian columns that stand atop a base of seven stairs, under a band of entablature, are one of Lexington's landmarks. Stone lions on either end serve as sentries to protect the peculiar sight on a farm near the intersection of Ironworks and Paris Pikes.

Yet the columns are all that remain of the great mansion. James Ben Ali Haggin had his Kentucky mansion, Green Hills, constructed around the turn of the twentieth century as a gift for his second wife, Margaret Voorhies.

The columns, stairs and twin lions are all that remain of the Green Hills mansion, which was the centerpiece of Elmendorf Farm. *Courtesy of the University of Kentucky Libraries.*

JAMES BEN ALI HAGGIN

Haggin was a native son of Mercer County, Kentucky, with generations of Haggins born there since Captain John Haggin settled in Harrodsburg in 1775. Captain Haggin was even among those with William McConnell at the campsite when the city of Lexington was named.

On the other hand, James Ben Ali Haggin's mother had very short Kentucky roots. She was the daughter of a Turkish soldier. Haggin's maternal grandfather, Ibrahim Ben Ali, was born in Constantinople in 1756 and is considered to be one of the first Turkish immigrants to the United States. Because of his unique appearance, those describing James Ben Ali Haggin often noted his short stature and "slightly Oriental appearance" handed down from his Turkish ancestors.

Haggin made his wealth in gold, silver and copper in California. When gold was discovered near the Pacific in 1849, Haggin joined the gold rush after arriving in the Golden State in 1852. The following year, Haggin would partner with Lloyd Tevis, and later with both Marcus Daly and George Hearst, to become one of the most powerful mining magnates of the nineteenth century. By 1880, he was a multi-millionaire.

Haggin was also a horseman with significant equine holdings at his Rancho del Paso. The winner of the 1886 Kentucky Derby, Ben Ali, trained at Rancho del Paso, though it had been born in Lexington after being sired by none other than Dr. Elisha Warfield's Lexington. Rancho del Paso was located in California' Sacramento Valley. Originally part of a Mexican land grant, Haggin had acquired the land interest in 1862. Haggin ceased using the ranch as part of his breeding operation in 1905, having turned toward Kentucky and Elmendorf Farm for that purpose.

Haggin relocated from California to New York in 1890, but his first wife passed away in 1897. He soon married his late wife's young niece, Margaret Voorhies of Versailles, Kentucky.

ACQUIRING ELMENDORF FARM AND THE ERECTION OF GRANDEUR

After briefly searching for a location in the east to establish his horse operation, Haggin acquired a 545-acre tract, six miles from Lexington, along what was then known as the Lexington and Maysville Turnpike. Its prior

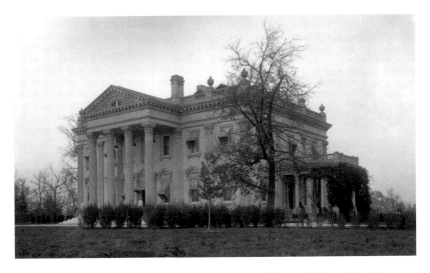

The Green Hills mansion was opened as the autumnal home of James Ben Ali Haggin and his wife in 1902. The mansion was demolished in 1929. *Courtesy of the University of Kentucky Libraries.*

The opulence seen in Green Hills' dining room carried through each of the mansion's forty rooms. *Courtesy of the University of Kentucky Libraries.*

owner, Daniel Swigert, had named the farm Elmendorf in 1881. With 140 stalls, it was a good-sized facility. But under Haggin, Elmendorf would grow to an immense 8,900 acres; the acreage stretched beyond Fayette County into both Scott and Bourbon Counties. Haggin would ultimately have two thousand horses on its grounds. It was unparalleled as "one of the most up-to-date and productive" breeding operations in the early twentieth century.

The marble mansion itself cost $1 million to build, and the cost of land acquisition and other improvements brought Haggin's total investment in Elmendorf to twice that sum. In today's dollars, this would be in excess of $200 million!

The opulence within the forty rooms of Haggin's Green Hills at Elmendorf included gold accents, ornate friezes, fine woods and elaborate beauty. It is said that the dining room table could seat one hundred. It is safe to say that no expense was spared in the building and keeping of Green Hills. In a 1904 account of the property by Thomas Knight, Green Hills and Elmendorf were compared to Asheville, North Carolina's Biltmore Estate:

> *In erecting a white palace in the Blue Grass Region of Kentucky, and in preparing a site for it, Mr. J.B. Haggin did for the State what Mr. George Vanderbilt did for North Carolina—took the natural features of a landscape rich in possibilities and, sparing no expense or labor, developed it to the highest point of which art and invention is capable. A succession of terraces and sloping hills spreads out in a panoramic vista as one approaches the dwelling, so vividly green that the place seems to have been christened by Nature herself—"Green Hills."*

A GRAND AFFAIR

On October 22, 1902, a festive affair occurred in Lexington as the Haggins opened the doors for the grand reveal of their new home. The *Lexington Leader* reported:

> *Unusual interest centers today in the cotillion to be given tonight by Mr. and Mrs. Haggin at Green Hills, their palatial country place on Elmendorf farm. Scores of guests have arrived from nearby and distant cities and are quartered at the hotels or with friends. The caterers and decorators have several special cars sidetracked at Muir Station, a few miles from Elmendorf.*

The following morning, the *Lexington Herald* noted that the mansion was "dedicated with a huge party." It would become an annual affair when Mr. and Mrs. Haggin would arrive in central Kentucky each autumn. Their annual stay lasted between four and eight weeks.

Each year, a "festive array" welcomed the Haggins' guests and they would regularly entertain both "the Lexington and country people." Haggin would employ and bring to Lexington large orchestras for his galas, where they would play for the people to dance.

But after a few autumnal months each year, the Haggins would return to their New York and Rhode Island residences, leaving Green Hills and Elmendorf to function under their careful farm managers.

OTHER HAGGIN INFLUENCES IN LEXINGTON

Despite spending most of the year away from Green Hills and Elmendorf, Haggin's Kentucky empire grew. Some of the growth was a natural extension of having such a significant horse breeding operation at Elmendorf. In a textbook model of vertical integration, Haggin owned rail lines in town to carry and supply all his own grain, hay, flour, feed, seeds and coal for his equine operations. Excess was made available to others at a profit. Haggin's

The Bluegrass-Elmendorf Grain Corp, at 321 Henry Street in Lexington, stored necessary feed and other items to supply Haggin's Elmendorf Farm. *Courtesy of the University of Kentucky Libraries.*

109

Bluegrass-Elmendorf Grain Corporation was an instrumental part of this vertical integration strategy. The home of the grain company can still be spotted on Lexington's Henry Street.

In 1913, Haggin had constructed Main Street's Ben Ali Theatre. It was one of several buildings erected on Main Street by Haggin. It has been suggested that the theater was built for his wife, after her box at the Lexington Opera House was found "inadvertently occupied by strangers." Only two years after opening, the theater was converted into a movie house and was itself demolished in the mid-1960s.

THE DEMISE OF GREEN HILLS

In 1914, at the age of ninety-three, Haggin died. Nine years later, the tracts most integral to Elmendorf were sold to Philadelphian Joseph Widener in 1923. At this point, Green Hills was unoccupied. For several years during the mid-1920s, Widener considered establishing a rehabilitation and treatment home for crippled children in the old mansion. The proposal was met with widespread approval from both the private and public sectors, but the idea would not materialize.

Ultimately, the high property taxes associated with the unoccupied mansion became too much for Widener. He had the mansion demolished in 1929, leaving only that which remains today—the columns—as a "mute testimony" to the fabulous structure that once here stood.

INGLESIDE

Almost at the gates of Lexington, on the Harrodsburg Pike, stands Ingleside like
some Old World castle with its battlements and ivy-covered walls, its lodge and
park of ancient forest trees.
—Thomas Arthur Knight

The work of John McMurtry was unparalleled in 1850s Lexington, Kentucky. A few of the residences attributed to McMurtry in those days included the landmarks Botherum and Elley Villa, as well as two companion castles, Loudon and Ingleside. This list is hardly exhaustive of McMurtry's inventory, as he was involved (either as lead architect or as the builder) in the construction of over two hundred buildings in central Kentucky.

Recounting McMurtry's genius in 1938, the *Lexington Leader* found he was "born with talents of originality, and also of memorizing details of construction of other artists that accounts for a wide and striking range in his architecture." At age twenty-one, McMurtry became an apprentice under the tutelage of another great architect of the region, Gideon Shryock. This apprenticeship marked the beginning of McMurtry's architectural career.

One of the notable McMurtry structures that no longer can be seen in Lexington is the residence that once proudly stood in the midst of a three-hundred-acre estate on the road to Harrodsburg: Ingleside.

The dominant tower of Ingleside, a Gothic Revival residence that was demolished in 1964 in favor of an expanding mobile home park. *Courtesy of the Historic American Buildings Survey (Library of Congress).*

A GOTHIC REVIVAL

The date "1852" was carved into the dominant tower of the stunning Gothic Revival residence that had been constructed in that year. Joseph Bruen, a prosperous iron manufacturer, had acquired the property nine years earlier. Bruen's daughter, Elizabeth, married Henry Boone Ingles, and Bruen pledged to build his daughter and her new husband a residence on the land as a wedding gift. The home took Ingles's name, as it became quickly known as Ingleside.

Ingles managed his father-in-law's iron foundry at the time of construction, and many of the cast iron features, including pinnacles and "dripmolds over windows and doorways," on Ingleside were created at the foundry, which was located on West Main Street.

The structure was quite similar in style to its McMurtry companion, Loudon House. Loudon House remains standing as the centerpiece of Lexington's Castlewood Park. The similarities do not make the houses identical, but both are reminiscent of the great castles of England.

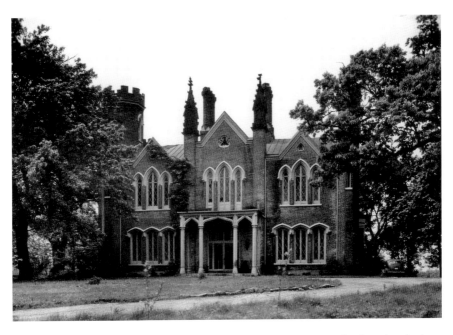

The almost-symmetrical façade of Ingleside once stood at the center of a three-hundred-acre estate along Lexington's Harrodsburg Pike. *Courtesy of the Historic American Buildings Survey (Library of Congress)*.

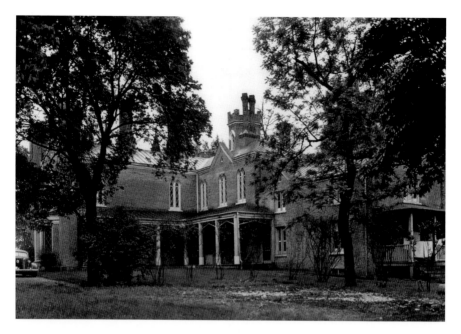

A view from the rear of Ingleside showing the L-shaped veranda and a perspective on the location of the residence's dominant tower at center. *Courtesy of the Historic American Buildings Survey (Library of Congress).*

The importance of the foundry to the Ingles family likely played a role in some of the design choices. Ingleside's finest features were cast in iron rather than etched in stone, as was the case at Loudon House. Loudon's front façade stretched the length of the structure while Ingleside extended further back from its front wall, creating a somewhat symmetrical appearance.

No bedroom chambers were built on the first floor of Ingleside; all six were on the second floor. The first floor contained both a large drawing room and a parlor on either side of the hall that stretched from an entry portico to what would have been a sizable veranda. The hall itself was of an open design and did not contain a grand staircase to the second floor, as would be expected. Rather, this necessity was located off a second "stair hall" between the parlor, library and dining room. Built in an "L" shape, the rear service wing included pantries and a kitchen behind the dining room. Again, iron mantels highlighted the Ingles's familial connection to the forge. The author of the 1922 *History of Kentucky* observed that McMurtry gave Ingleside "all the characteristics of the old

English period, its rooms being large and high, and it was finished and furnished magnificently."

In 1868, the family sold the significant acreage to Colonel J.W. Kearney, who in turn sold the property again to the Colonel and Mrs. Gibson.

COLONEL AND MRS. GIBSON

Colonel Nathaniel Hart Gibson, commonly referred to as Hart Gibson, was born in Mercer County in 1835. Well-educated by private tutors in both Lexington and Louisiana, he graduated from Yale before studying law at Harvard. He then completed his studies at Germany's Heidelberg University. On returning to Kentucky, he received his first commission as a Kentucky Colonel, bestowed as an aide de camp to Governor Beriah Magoffin. Gibson was married to Mary Duncan, the daughter of prominent Lexingtonian Henry T. Duncan. In 1862, Gibson became a colonel for the Confederate army led by General Kirby Smith.

Left in Lexington by her warrior husband, Mrs. Gibson seemed perfectly capable when left to her own devices; she was as committed to the Southern cause as was her husband. An entry dated April 7, 1863, in the diary of a young Union sympathizer, Frances Dallam Peter, records Mrs. Gibson's Southern allegiance:

> *Last Thursday night while Gen Burnside and a number of other gentleman who had been invited to meet him were at Mr Davy Sayres* [sic] *and while the gentlemen were speaking to the crowd from the door, they were continually hissed by Mrs Hart Gibson and her sister Miss Ella Duncan, who had gone into the house without the knowledge of Mr or Mrs Sayre or their father, Mr Henry Duncan Sr. who was in the house at the time and stationed themselves by the open window of the little room over the hall, the windows being just over the front door where the speakers were standing.*
>
> *When the band played national airs these women sung "Bonny Blue Flag" "Dixie" and other secesh* [sic] *songs, and when Gov Robinson in his speech said very warmly "The Union must be preserved, it will be preserved, and it shall be preserved" the hisses were so distinctly heard that the crowd was with difficulty restrained from stoning the house. And then these creatures had the impudence to come down and send for Gen Burnside to come out into the hall and be introduced to them.*

The disdain dripping from the pages of Peter's diary reveals the emotional toll that the war took upon a divided Lexington. Meanwhile, outside Lexington, Gibson had already joined General John Hunt Morgan's cavalry and would soon join the Thunderbolt of the Confederacy during the Great Raid into Ohio.

Along with General Morgan and others under his command, Hart Gibson was captured by Union forces in Ohio. He was then transported by Union guard to the Ohio State Penitentiary, where he remained in federal custody for sixteen months. Gibson was not among those who escaped with General Morgan, though Mrs. Gibson's sympathies may have played a hand in the effort.

President Lincoln permitted Mrs. Gibson to cross enemy lines to visit her husband behind bars, an arrangement not wholly unusual. During one of these visits, it is believed that Mrs. Gibson brought her husband a pair of newly made boots. In the heel of one of the boots, Mrs. Gibson hid disguised money for use by General Morgan following his escape. The *History of Kentucky* published by the American Historical Society in 1922 noted that, "though unchronicled, [Mrs. Gibson's] services for deeds of kindness and generosity, her fortitude and courage, run parallel to those of Colonel Gibson's, who gave to the South all of which he was possessed in valorous acts and material substance."

It may be better said, however, that all of Colonel Gibson's possessions of "material substance" were given to the Union rather than to the Confederacy. After all, an Act of Congress in 1864 resulted in the confiscation by the Union of Colonel Gibson's estate in Woodford County. It was a minor setback, as he quickly earned a seat in the state legislature representing that county after returning from war. By 1870, he would co-found the *Lexington Daily Press* with his brother-in-law, Henry T. Duncan Jr.

In 1879, Colonel and Mrs. Gibson relocated permanently to Lexington after acquiring Ingleside from Colonel J.W. Kearney. The home's magnificence from the Ingles's years of ownership was sustained by the Gibsons, who also hosted a number of prominent persons while they lived here.

While visiting his daughter in Minneapolis in 1904, Colonel Gibson passed away. His body was brought back to Ingleside for a funeral, and his burial would follow in Lexington. Despite the Civil War having been over for almost half a century, the cause for which Colonel Gibson fought was on display at his funeral, with the flag of the "Lost Cause" being prominently displayed. Also during the funeral, the residence "caught fire during the

funeral services" though "a quick response was made by the fire department" according to accounts in the *Lexington Leader*.

Mrs. Gibson would follow her husband in death in 1910 at Ingleside. In reporting her death, the *Lexington Leader* remarked that she was "one of the widely-known and best beloved women of the Blue Grass."

THE AUCTION BLOCK AND AFTERMATH

In 1924, the Gibson heirs began the process of dividing the significant acreage that had once been a part of the Ingleside estate.

Lots along the Harrodsburg Road were among the first to be separated from the main tract. Among these subdivided lots was the old gatehouse to Ingleside. It is curious that, although the gatehouse was among the first properties to be taken from the Ingleside lands, it is the only remaining physical vestige of Ingleside. Following subdivision, the gatehouse was converted to residential use. Its iron gate was removed, and the passage for carriages was filled in. Today, the old Ingleside gatehouse offers office space under its unique tooth-edged roofline.

After Mrs. Gibson's death, the residence proper remained in the family for another twenty-one years. In 1931, however, an auction offered the "place known and admired throughout Kentucky…without reserve to the highest bidder" according to the *Lexington Leader*. The buyer, Eldon S. Dummitt, paid $12,100 for the fourteen-room residence and its grounds.

That same year, the City of Lexington released its first comprehensive plan, a plan credited as the first comprehensive development plan for a city in the United States. Within that plan, it was proposed that thirty-three acres of the old Ingleside property be developed as a city park, similar to what had been done in Castlewood Park with the Loudon House. Though never developed, Ingleside Park was proposed to contain both a "little children's playground and probably a stadium," with the old mansion serving at the center of the park as a community center. The property was deemed highly suitable for such a purpose with its "many good trees, its gently rolling topography, and the large old building that…could be remodeled into a community recreation building."

Ingleside Park, however, was not to be. During the 1940s, the property passed into the hands of Mr. E.H. Palmer. Palmer converted much of the land into a trailer park and the manor into several apartments. Ultimately, the trailer

The gatehouse that once welcomed visitors to Ingleside through a central arch that was filled in long ago. The gatehouse was the entryway to the three-hundred-acre estate. *Author's collection.*

park was expanded and, in 1964, the old Ingleside Manor was demolished. For a number of years, the mobile home park offered pleasant and affordable housing for many young families, especially those attending graduate school at the University of Kentucky. But the ensuing decades witnessed deterioration in the conditions and environs of the Ingleside Mobile Home Park. At the advent of the twenty-first century, condemnation proceedings against the Ingleside Mobile Home Park prompted its removal as well.

The site where a grand Gothic Revival castle once stood is now the location of nondescript apartments, leaving only a severely modified gatehouse as a reminder of the legendary Ingleside. The city is fortunate, however, to have preserved the grand sister of Ingleside—the Loudon House, which remains a community landmark.

CHAUMIERE DES PRAIRIES

Immediately south of Lexington's Fayette County is Jessamine County. The division of Jessamine and Fayette Counties occurred in 1798 in what was the final separation of land from the once-massive Fayette County. The existing borders of Fayette County were completed on this division, leaving behind a geographic fragment of what was once one of only three counties in all of Kentucky.

In the early 1790s, along what is today Catnip Hill Road, a Virginian acquired some 330 acres in a portion of Fayette County. His land would be part of the new Jessamine County formed in 1798.

The Virginian was Colonel David Meade, and it was on this parcel that he would create his version of paradise. The moniker is one by which neighbors recognized the beauty of the colonel's estate. Once destroyed, those neighbors erected a sign over the entrance to the estate, with a Miltonian reference to the expulsion of Adam and Eve from the Garden of Eden: "Paradise Lost."

AN EDEN WITHIN EDEN ITSELF

In order to understand the significance of Chaumiere des Prairies, one must understand its place within its larger setting.

The Chaumiere des Prairies property was located nine miles to the south of Lexington—a city once known as the Athens of the West. With its rich

soil perfect for the cultivation of tobacco and hemp, Lexington was an economic center. With this prosperity came literacy, the arts and gaieties that were uncommon in the early nineteenth century, particularly on the frontier. The town grew in significance and import, as well as in number. By 1825, Lexington's population had risen to 5,517. While the number seems small today, Lexington was once the largest town west of the Alleghenies.

On his first trip to Lexington, Dr. Horace Holley found "Lexington handsomer than…expected, and [having] a more comfortable and genteel aspect. It has not the pretension without the reality, that so many…towns have." Holley would become the first president of Transylvania University. It has been suggested, on more than one occasion, that without either Holley or Transylvania, Lexington could not have achieved its lofty label as the Athens of the West.

Amos Kendall, a New Englander who would settle in Frankfort and would later become an ardent supporter of and advisor to Andrew Jackson, found the region "one of the most beautiful spots I ever beheld." The region's rolling hills and endless streams have long been recognized as a paradise.

At the heart of the region, however, was paradise unlike any other. Visitors to the Athens of the West traveled the extra nine miles so that Meade might entertain them at his Chaumiere des Prairies.

On one occasion, James Craik, the rector of Louisville's Christ Church, accompanied Dr. Holley on a visit to the home of Colonel Meade. Craik observed, "Everyone who went to Lexington, or to any part of the Bluegrass country visited Chaumiere as a matter of course, to enjoy the wondrous beauty which the taste and genius of one man has created."

It was true. The list of individuals trekking to the Chaumiere included some of the most significant individuals of the era. Among the distinguished guests were presidents of the United States James Monroe, Andrew Jackson and Zachary Taylor. General Charles Scott visited Meade's estate and both Dr. Holley and Henry Clay were regular guests. The list could continue.

Two notorious guests also visited, though they were not invited to enjoy the colonel's hospitality or to simply stroll the grounds on this occasion. David Meade III, the son of Colonel Meade, was appointed deputy marshal for Kentucky. In that capacity, Meade III arrested former vice president Aaron Burr, as well as Burr's accomplice, on charges of treason. Meade III lodged Burr and Harman Blennerhassett for three weeks at his father's Chaumiere while en route for the pair to stand charges at Richmond, Virginia.

But of the many visitors who called at Chaumiere, Dr. Holley appeared to have been one of the most frequent. He wrote a description that is one of the most vivid accounts of the great estate:

The extant Greek Revival residence, circa 1840, and the earlier circa-1823 octagonal parlor of the Chaumiere des Prairies as seen in 2014. *Author's collection.*

[Chaumiere] *consists of a cluster of buildings in front of which spreads a beautiful sloping lawn, smooth as velvet. From this walks diverge in various directions forming vistas terminated by picturesque objects. Seats, verdant banks, alcoves, and a Chinese temple are all interspersed at convenient distances. The lake over which presides a Grecian temple, that you may imagine to be the home of the Water Nymphs , has in it a small island which communicated with the shore by a white bridge of one arch. The whole park is surrounded by a low, rustic stone fence almost hidden by roses and a honey-suckle, now in full flower. You enter from the road through a drive, which winds through a noble park; to a minor gate, the capitals to whose pillars are formed of roots of trees, carved by nature. There the rich scene of verdure and flower capped hedges burst upon you. There is no establishment like this in our country.*

The Chaumiere des Prairies received accolades from Dr. Holley and nearly all who visited. It was truly "the first lordly estate in Kentucky."

A DAY AT CHAUMIERE

So what might have Holley or another guest found during his day at this lordly estate?

For one, a guest's arrival needn't be announced. Meade was "entirely a man of leisure," and it apparently offended him if his guests found the need to warn him of their coming. Holley noted that on one occasion, "twenty of us went out one day without warning, and were entertained luxuriously on the viands of the country. Our drinks consisted of beer and wine." Meade kept the table ready for any number of guests at any given time; his hospitality was unparalleled. Smoking and chew, however, were prohibited at Chaumiere des Prairies, as Meade found the use of tobacco distasteful.

Written accounts of the dinners at the Chaumiere reference what can only be believed to be exaggerations, but the embellishment of every element of Meade's life hint that there might be reality in each suggestion. For example, one hundred settings of both china service and crystal stemware were always at the ready.

Colonel Simeon Anderson attended one such feast for Christmas Day dinner in 1825. Of the dinner, Anderson remarked in a letter that, "the entertainment given by Col. Meade at 'Chaumiere' on the 25th to about one hundred guests, I think, in management, in order, in simplicity of style, and without the least ostentation though all the surroundings were profusely rich, surpassed anything of the kind I have ever witnessed."

Not only were his home unique, his gardens divine and his table well appointed, but Meade's appearance also could not be ignored. It was said that Colonel and Mrs. Meade "made no change in the fashion of his attire for half a century." Thus, as he welcomed guests throughout the first three decades of the nineteenth century, his attire reflected the dress of colonial Williamsburg, Virginia, around the time of the Revolution: "coat, short breeches, and the long waistcoat reaching to his hips, were of light drab cloth. His white or black silk stockings were held up by jeweled knee-buckles and a similar pair adorned his low shoes." Missing only was a powdered wig.

The house itself was well appointed with art curated from among the houses of England and Europe. The piano in the house was reputed to be the first brought into Kentucky. It was, according to Holley, a pianoforte that Mrs. Meade played "with the facility and cheerfulness of a young lady."

One visitor who sadly did not visit the Chaumiere des Prairies was Alexis de Tocqueville. The Frenchman, author of *Democracy in America*, was trapped on the frozen Ohio River when he disembarked at Westport in Oldham

County, Kentucky, to walk the twenty-two miles to Louisville and, ultimately, head south toward Nashville. His commentary on Kentucky was not kind, including several digs at both the Commonwealth and her people:

> *Nothing is more unusual that to see a brick house in Kentucky.*
> *Nothing in Kentucky…gives the impression of such a finished society.*
> *Kentuckians are well known through the union for their violent habits…*
> *They seem to deserve that reputation.*

De Tocqueville may have seen a small part of Louisville before traveling southbound, but he approached neither the Athens of the West nor the Chaumiere des Prairies. Had he, he would have found it necessary to tell a different story of Kentucky.

PARADISE GAINED

David Meade was born in 1744 in Virginia to a family whose lineage traced through Oliver Cromwell and the kings of Ireland. His education included a decade in England, exposing him to beautiful English estates and the finest in hospitality. His return to America ultimately found him in Virginia's then-capital, Williamsburg. There, he married Sarah Waters, and the couple established a home at Maycox, a sprawling six-hundred-acre estate on the James River. During his time at Maycox, Meade's wealth grew. He transformed the Virginia landscape he owned for some twenty-two years with "natural woods and fruit trees together with artificial hollows and rises covered with well manicured grass."

Meade's penchant for both "landscape architecture and hospitality" was practiced at Maycox and it was later perfected at Chaumiere. In 1795, Meade sent his eldest son to Kentucky, where the land for the future Chaumiere des Prairies was acquired from Andrew McCalla.

Then, on June 17, 1796, Meade left Virginia for the "wilds of Kentucky," along with his wife, nine children and their servants. The Meade family traveled up to Pittsburgh, Pennsylvania, before hiring a boat to navigate the Ohio River. On arriving at Limestone (now Maysville, Kentucky), it required twenty-one horses and fifty wagons to haul the personal property brought by the Meade family overland down the turnpike to Lexington and further to the grounds of the Chaumiere.

The motive behind Meade's relocation of his family from the James River to the Bluegrass is unclear. It has been suggested that only a small portion of Maycox's acreage was of good soil and that Meade sought more fertile ground in Kentucky. Others theorize that financial losses incurred during the American Revolution prompted Meade to liquidate his significant land holdings in Virginia. The cause, however, does not change the fact that the family relocated to Kentucky. As the first temporary log house was completed at Chaumiere, the family remained in Lexington.

Joseph Prentis of Williamsburg, Virginia, was Sarah Waters Meade's uncle, and he advised Colonel Meade on several business matters, particularly during the years surrounding the transition into Kentucky. Prentis and Meade corresponded frequently by letter, and Meade routinely updated Prentis on the status of things at Chaumiere.

On August 14, 1796, Meade wrote that the Chaumiere consisted of an intimate connection of log houses forming "one mansion of five rooms." From the mansion's entrance, one entered a wide hall that led to a twenty-square-foot dining room. A second hall, perpendicular to and bifurcated by the first, provided an entrance to the four original bedrooms. Off the most eastern chambers, the circa 1823 addition that included the octagonal room was added. A progress report from Meade to Prentis in September 1798 suggests the trappings of a more complete residence:

> We have just finished two additional bedrooms which are of frame work— wainscotted [sic] chair board high and cornices with hearths of wrought stone from a quarry at our best spring which affords good stone and the best water in the neighborhood…I will be bold to say that [my eldest daughter, Sally] is as well lodged as any of our friends or acquaintances in Virginia when the little improvements I am making to the interior parts of a log building are finished. I think we shall have an elegant kind of Chaumiere for I will not dignify my collection of rooms with a name of higher class amongst buildings.

A breezeway beyond the two new chambers led to the sizable kitchen (forty-four feet by twenty-two feet) that was ultimately completed in 1806. The kitchen marked the largest structure, bordering a square hen yard, with other buildings around the yard including a dairy, a privy, two cabins, two hen houses, a whiskey house and a smokehouse. This historic layout was based on an original floor plan drawn by Meade, circa 1795. The noted architect, Clay Lancaster, utilized the original sketch by Meade to create a perspective of how the Chaumiere would have once looked.

Clay Lancaster's sketch of the original layout of the Chaumiere des Prairies. *Courtesy of the Warwick Foundation.*

It appears that the "mansion of five rooms" was replaced or added to, possibly with a second story. This modification is reflected in the circa 1815 watercolor painting by Maria Von Phul. Von Phul was a young woman from Lexington and a friend of the Meade family. As noted in the property's nomination form to the National Register of Historic Places, the watercolor "painting shows the house at a later stage when some of the one-story portions had been raised to two, and perhaps converted to brick construction."

The second story may have been added after 1813, as suggested by Anderson's letter that commended the Christmas dinner of 1818, "the Colonel has greatly improved his residence since I saw it five years ago. His house is large, and the magnificent rooms are furnished." Based on the dates of the other improvements completed to the Chaumiere des Prairies, it is possible that the great improvement referenced by Anderson was the addition of the second story to the main section of the mansion.

Meade made a final major modification to the house's floor plan with the erection of the octagonal parlor added circa 1823. It is believed that Meade built the addition in anticipation of a visit to the property by the Marquis de Lafayette. However, there is no evidence that Lafayette ever visited the Chaumiere. Lafayette did, however, visit Lexington in 1825.

There is no certainty as to how the octagonal parlor related to the original house. An archeological dig in the 1970s at the site proved inconclusive. In *Paradise Lost*, Mary Oppel writes that the octagonal parlor was "reportedly the only brick portion of Chaumiere…entered through a small vestibule with

A view of the mansion, Chaumiere des Prairies, in Jessamine County. Watercolor by Anna Maria Von Phul, circa 1815. *Missouri History Museum, St. Louis.*

Chinese Gardens at the Chaumiere des Prairies in Jessamine County. Watercolor by Anna Maria Von Phul, circa 1815. *Missouri History Museum, St. Louis.*

small dressing rooms or closets on either side. The octagon is spacious and well proportioned with a high ceiling. All woodwork is black walnut. Although the exact relationship of the parlor to the original portion of the house is unknown, it is believed to have been located to the right of the dining room." If the suggestion of a two-story brick modification of the main mansion based on Miss Von Phul's watercolor is correct, then Oppel is errant in her assertion that only the octagonal parlor was of brick construction. Oppel also suggests that the parlor might have extended from the dining room, while Clay Lancaster opines of its location at the east end of the residence's front rooms.

The location of the parlor suggested by Clay is more persuasive. Given its unique architectural shape and design, it is unlikely that the parlor would have been placed with windows looking into the back of the main mansion, which would be the case if it were built off the dining room. Alternatively, the location at the end of the home's front rooms would provide sweeping views of the grounds from each of its windows, as well as a few views of the parlor itself on arrival at the Chaumiere. Given Meade's penchant for grandeur, it is almost certain that the octagonal parlor was added to the eastern edge of Chaumiere's primary structure.

Of Chaumiere's landscape, Meade's granddaughter wrote: "The grounds were extensive and beautiful; at that time it was said there was not so highly and tastefully improved country seat in America…And then the walk—the serpentine one-mile around…and in a secluded nook, a tasteful Chinese pavilion. The birdcage walk was cut through a dense plum thicket, excluding the sun, and led to a dell, where was a large spring of water, and the mouth of a cave. At this point was the terminus of the lake, and…a waterfall."

A second watercolor painting by Von Phul, also completed circa 1815, shows the beauty at Chaumiere through her depiction of a bridge in the "tasteful Chinese pavilion." Clay Lancaster noted the bridge's railing as having a "Chinese lattice design."

Taken together, there was nothing but glowing remarks of Meade himself, of his hospitality, his home and the grounds of Chaumiere. Holley wrote, "There is no establishment like this in our country."

PARADISE LOST

Chaumiere des Prairies was truly a site to behold. But Colonel Meade died in 1832, at the age of ninety-four. His will instructed only that Chaumiere be kept "as he made it" for at least three years following his death.

Yet, in 1835, three years after Meade's death, "a large crowd collected to hear lovely 'Chaumiere' cried off." The buyer has most commonly been described as a "plain practical farmer," but those who long for Chaumiere and prefer the preservation of historic properties and lands might appreciate the description of the buyer as provided by Meade's great-granddaughter, Mrs. Anna Meade-Letcher: "a coarse, vulgar man."

In a letter, Mrs. Letcher described the scene that followed. Her account was undoubtedly second-hand and reflected the emotions of family members who witnessed the destruction of their patriarch's life's work. Mrs. Letcher wrote:

> *So surprised and indignant was everyone that a murmur of disapproval was heard, and soon after was seen in large letters on the pleasure-houses all through the grounds—Paradise Lost. This so enraged the purchaser that he determined to make these words true. In less than a week the beautiful grounds were filled with horses, cattle, sheep, and filthy swine. He felled the finest trees in the grounds and park, cut down the hedges—in fine, committed such vandalism as has never been heard of in this country. He pulled down some of the prettiest rooms in the house, stored grain in others and made ruins of all the handsome pleasure-houses and bridges through the grounds. He kept only the place long enough to destroy it.*
>
> *The next purchaser found Chaumiere but a wreck of beauty. It seems as if Providence decreed that the glory of the beautiful old Chaumiere should depart with the name of Meade.*

It was that next purchaser who, having little with which to work, set about to build the Greek Revival residence that remains standing today. Of Meade's Chaumiere, only the circa 1823 octagonal parlor remains. The neighbors' cries could not have been more accurate. It truly was and is a "Paradise Lost."

TOWN BRANCH

In the summer of 1775, a small band of men of varying backgrounds camped at a location along a branch of the Elkhorn Creek. The group largely hailed from Pennsylvania and was led by William McConnell. The spot would later be known as McConnell's Spring. Only two months prior, Paul Revere had warned the Minutemen of the arrival of British troops on the eve of the Battles of Lexington and Concord. And it was near their encampment where the party learned of the significant battles and gave the place its name: Lexington. It was the dawn of both this country and of the community that would become Lexington, Kentucky. The McConnell party would return to Pennsylvania so they could make final preparations for a more permanent move to the "Edenesque" Kentucky later in the year.

Though Lexington was not the first settlement in Kentucky, it would soon become one of the most significant. Other settlers, like Robert Patterson, who were already living in forts on the Kentucky frontier, would soon join those in the McConnell party to help establish a permanent settlement here.

And so it was in the evening on April 16, 1779, that the party arrived at what would become known as the Town Branch, or the Middle Fork, of the Elkhorn Creek. Of the site selection, John Wright wrote in *Lexington: Heart of the Bluegrass*:

No one knows exactly why this particular spot was chosen. Though adjacent to a pleasant stream and a number of good springs, the location suffered from being on a flood plain with a sharp rise on one side and a more gradual

Looking west, the Town Branch emerges above ground to the west of Rupp Arena. *Author's collection.*

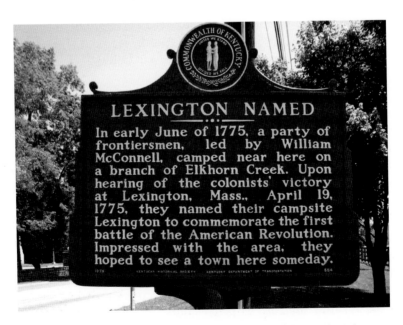

LEXINGTON NAMED

In early June of 1775, a party of frontiersmen, led by William McConnell, camped near here on a branch of Elkhorn Creek. Upon hearing of the colonists' victory at Lexington, Mass., April 19, 1775, they named their campsite Lexington to commemorate the first battle of the American Revolution. Impressed with the area, they hoped to see a town here someday.

A historic roadside marker near McConnell Springs notes the naming of Lexington after the Revolutionary War battle. *Author's collection.*

A map of Lexington drawn by Cecil C. Harp, circa 1838. The Town Branch features prominently across the lower third. *Courtesy of the Town Branch Trail Incorporated.*

on the other. This made any settlement or fortification subject to easy enemy surveillance and musket and light artillery fire. Also, the site was vulnerable to periodic flooding since it was confined to a small flood plain between two slopes, which acted as natural dams.

Despite its flaws, the settlers began erecting a blockhouse on the site. The nearby water source provided both nourishment and energy. The Town Branch would power the turning of many millstones in Lexington's early history. The first blockhouse was completed in short time, and additional settlers arrived through the summer and fall of 1779. Within the year, early town leaders drew the first plat for Lexington. Platted were a grid of "in-lots," which were rectangular in shape, as well as several five-acre "out-lots" to both the north and the south of the interior grid. Near the center, a public square was reserved for the courthouse.

The references to the plat's cardinal points, however, were never true. The axis on which Lexington's streets were drawn aligned not with a compass, but instead only with the course of the Town Branch itself. That earliest plat of Lexington revealed roughly six blocks of in-lots, east to west, to the north and south of the Town Branch. The course of

the Town Branch, of course, is not perfectly straight. So since the city's earliest days, the course of the stream was manipulated for the benefit of the community's inhabitants.

According to George W. Ranck's *History of Lexington*, the town "trustees ordered a 'canal' to be dug to carry the water of the 'Branch' straight through town in 1790. They also made the announcement that 'the town commons shall hereafter be known as Water street." The waterway was referred to for a time thereafter simply as the "Canal."

The Canal, however, was hardly sufficient to contain its flow and it regularly overflowed. A bridge that crossed the Canal was overtaken during heavy rains in 1799. A decade later, the Canal was the "miserable Canal" as it "could not accommodate the water which ran from all the streets and high lots, and collected in the Town Fork of Elkhorn Creek," according to newspaper accounts.

The central portion of the Canal was covered, and buildings, such as residences and the city's market house, were built partly above the old waterbed. Alongside the banks were mills, tanyards and distilleries. The "miserable Canal" was miserable for another reason other than its inability to contain water flow: its contents were laced with a variety of contaminants ready to strike illness on the community. But no one knew that at the time.

From the 1790s, the keeping of an orderly town required the town trustees to order residents to maintain their properties in clean condition. Slaughterhouses were ordered to clean their premises, "so as to prevent any offensive smell." Others created drains on their property so as to avoid the "filth from running into the street therefrom." Even the construction of the market house atop the Branch inevitably meant the refuse from the market floor and vendors' tables and carts being cast right into the water flowing beneath. No doubt the Canal, at this stage, contained rotten fruit, trimmings from the butcher and all sorts of other rubbish.

A CONTAMINATION SOURCE

So just as the Town Branch was a source of water and power for the growing city, the Branch was also a source of disease. Lexington suffered from two significant outbreaks of cholera during the nineteenth century. The first occurred in 1833 and the second in 1849. Both originated near the Canal.

Today, we understand that cholera is an intestinal infection generally contracted from the ingestion of water contaminated with fecal material. The open-air Canal, coupled with the porous limestone soil prevalent in the area, contributed greatly to the spread of the disease as water sources quickly became contaminated. Outhouse construction was shoddy, at best, and privies often spilled their contents onto the ground, allowing the contaminants to leech into the soil.

At the time, however, this causal information was unknown. When the disease struck in 1833, even those at Transylvania's medical college did not understand the source of the deadly epidemic. Alternatively, it was a widely held belief that the contraction of cholera was airborne. The remedy? One physician suggested a mixture of calomel, aloe and rhubarb.

The population of Lexington at the time of the first cholera epidemic was in excess of six thousand. Within months, over five hundred Lexingtonians perished. Their names are recorded in the *Observer and Reporter* and the list reveals that cholera did not discriminate. The disease took people of all ages, across the social spectrum and from all walks of life. Nearly 8 percent of Lexington's population was decimated.

The monument over the grave of King Solomon (1775–1854) was dedicated in 1908 to the "hero of the 1833 cholera plague." *Courtesy of Nathaniel Kissel.*

In time for the 1849 epidemic, there was a little more awareness as to the cause of the disease. Terry Foody, a community nurse who has related the effects of the 1833 epidemic to today's pandemic and epidemic outbreaks, wrote of steps taken in advance of the 1849 outbreak:

> *Lexington prepared for a predicted 1849 cholera wave by enacting ordinances to clean up low-lying boggy places. Pigs were no longer allowed to roam free in the streets; although some residents argue that at least the pigs ate the offending garbage. A new privy ordinance decreed that said structures must be at least 2 to 4 feet deep with sides of wood or brick.*

One of the great characters in Lexington's history was William Solomon. A town drunkard, King Solomon buried so many of the dead during the 1833 epidemic. It is retold in Wright's *Lexington: Heart of the Bluegrass* that "because [Solomon] rarely drank water to quench his thirst he never contracted cholera, and that if any stray bacillus had entered his bloodstream it would have died immediately from the alcoholic content." Solomon would live until 1854 and was buried in the Lexington Cemetery. An impressive monument, paid for by the people of Lexington out of gratitude for his efforts, stands over his final resting place.

So Cover It Up

Beginning shortly after that second cholera epidemic, a short distance of the Town Branch was enclosed, with other sections following over the next half-century. In 1878, the status of the Town Branch was reported as both "very low and very offensive" according to reports in the *Daily Press*. The Town Branch enclosure was substantially lengthened in 1880 due to these conditions. And by 1890, the *Lexington Leader* reported "a movement is on foot to…build an arched sewer under Vine street…and turn the Town Branch into it just at the point where it curves." Another article in a later issue of the same paper noted that many of the cellars in buildings along Main Street were at depths lower than the Canal itself, revealing obvious deficiencies in the utility of the Canal. Flooding of these structures continued regularly and the Canal channel was deficient for the city's needs.

Waters were again low during the warm summer of 1891; it was then said of the Town Branch that there was "scarcely enough water in it to make a Kentucky Mint julep."

But when the rains came, the flooding could be devastating. In one anecdote from about 1812, a schoolboy living on High Street could not cross the Town Branch, except on the back of a friend's horse. And even then, the water covered the horse's back! In another story, the cellar doors of the Phoenix Hotel were fastened tight during heavy rains, else both bourbon and bacon might float away!

A scan of newspaper clippings from the nineteenth century reveals more of the same as the Town Branch was either raging far beyond its banks or else regularly filled with several feet of silt. It became so bad that criminal charges were levied against the city, including one count of "willful and criminal neglect in failing to keep the town branch in proper condition for sewerage and free from obstruction."

These newspaper citations neither forgot nor forgave the cholera epidemics for the pain afflicted on Lexington, and it was the Town Branch that bore that disease in the city. The contaminants spreading the disease seeped into the flow of the waters and from those waters to the people.

Finally, in 1899, work began to lower the bed of the Town Branch several feet to help alleviate the persistent flood complaints. The process would drag on for several years, with the work on the Ayres Alley viaduct and the Union Station being an impetus for completion of closing the culvert through which the Town Branch would flow.

During the 1930s, a project organized by the Works Progress Administration (WPA) made the most significant improvements to the Town Branch. These improvements followed dramatic floods that occurred in both 1928 and 1932. During this project, a second concrete tunnel was added parallel to the existing "brick-arched and moldy" tunnel to create parallel systems for evacuating both wastewater and runoff from Lexington. The effort proved successful for taming storm runoff as the era of a flooded Main Street was largely ended.

Issues, however, continued with Lexington's wastewater. In 1919, Lexington opened the Town Branch Wastewater Treatment Plant. It was one of the first such facilities in this region. Although upgraded many times, problems persisted. This, coupled with the industrial facilities and landfills near the Town Branch, created concern about the water quality of the stream for those at city hall and beyond. In 2000, the *Herald-Leader* observed that the "stream that literally shaped Lexington is classified as too nasty to support aquatic life."

Since, Lexington has entered into a settlement with the Environmental Protection Agency to resolve these and other issues related to violations of the

A subterranean tunnel under the streets of Lexington contains the Town Branch. *Courtesy of the University of Kentucky Libraries.*

Clean Water Act. Many steps have already been taken to improve the quality of Lexington's natural waterways, including the Town Branch. For the first time in decades, the Town Branch has become a positive as restaurants and other businesses are opening "waterfront" locations along its banks in late 2014.

A REBIRTH?

Town Branch has never been lost, nor has it been entirely forgotten. It has gently flowed under Lexingtonians' feet for decades. Lately, much effort is being made to raise the Town Branch again to the surface in an artistic and celebrated way that would bring a ribbon of water to Lexington's downtown. Is it possible that this piece of Lexington's lost history could again be found and brought forth to be a part of Lexington's daily life?

Technology and science can accomplish this feat without causing the problems that made the Town Branch distasteful in the first place: the filth, the disease and the odor. The editor of the *Lexington Leader* wrote in August 1911:

> *Shall Town Branch lose its most distinctive characteristic, its penetrating odor? Shall its sluggish agers become clear, and its course through the country be marked only by a modest and inoffensive flow to cross which one doesn't have to hold his or her nose?*

In fact, that is one part of the Town Branch that can remain buried and lost forever. But much beauty could be added to Lexington by the surfacing of even a portion of the Town Branch through the heart of the city. Already, the Town Branch surfaces just to the west of Rupp Arena's parking lots, and those in the city's Distillery District are taking great strides to utilize the waterway to economic advantage.

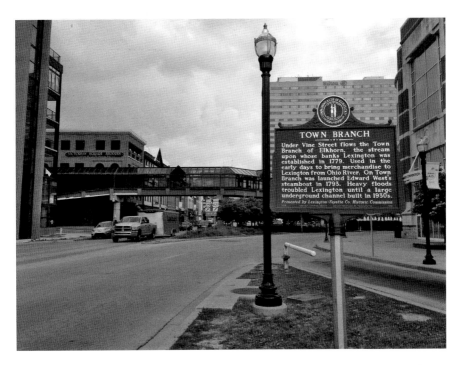

A historic roadside marker near Main and Vine Streets reminds travelers that under Vine Street flows the Town Branch. *Author's collection.*

In the 1980s, developers proposed creating Lake Lexington, which would have been a largely rectangular lake in the area roughly bounded by the Jefferson Street viaduct to the east, Main Street to the north, what is now the Oliver Lewis Way Bridge to the west and Manchester Street to the south. Developers of this proposal envisioned having Rupp Arena reoriented toward the new lake. A few slips included in the design suggested the possibility that sailboats, canoes or even some motorized vessels might take to Lake Lexington. This never occurred, of course, and the development never materialized.

Around 2002, a group of citizens began working to promote and return attention to the historic Town Branch. The Town Branch Trail Incorporated began an effort to create a multi-use trail along the surfaced Town Branch. A few years later, a proposal was floated to replace a portion of Vine Street with a promenade and open canal, as the street now covers the downtown portion of the Town Branch. More recently, a master plan envisioned a series of liner parks through downtown along the path of the Town Branch. The name of the proposal, the Town Branch Commons, harkens back to that early pre-1790 name of the city's commons.

Even the Town Branch name has experienced a renaissance of sort. A downtown corner market opened in 2011 at the corner of East Main and Esplanade under the name Town Branch Market. And in 2012, Alltech introduced Town Branch Bourbon.

A MODEL STEAMBOAT

A final twist on the Town Branch story involves another part of history that has largely been lost. In recollecting Lexington's history in 1914, the *Lexington Leader* proclaimed that the "Town branch bore on its bosom the world's first steamboat in 1793."

Robert Fulton is largely acknowledged as the inventor of the steamboat, though the New Yorker's credit should only be insomuch as his steamboat was the first vessel to be commercially successful. The suggestion has been made that Edward West invented a model steamboat that he publicly launched in the current of the Town Branch in 1793, long before Fulton's accomplishment. The launch was before hundreds of "curious townsfolk" who witnessed the model steamboat succeed "with great velocity" against the current of the Town Branch, which had been dammed up for the purpose.

The steamboat's history, however, does not support West's model steamboat as being the world's first. A brief steamboat voyage in France in 1783 and an American attempt in 1785 both preceded Edward West's launch. West's patent on the steamboat design was filed in 1802, though the reasoning for his nearly decade-long delay remains a mystery. Fulton would file his own patent the following year. Despite these earlier attempts and the commercial success of Fulton's steamboat over that of West, it is safe to say that Lexington's West was at the forefront of the day's technological advancement.

George W. Ranck described Edward West as being a "wonderful mechanics genius." It is easy to suggest that this sort of accomplishment was only a harbinger of what the coming decades would bring for Lexington as the Athens of the West.

Though there has been a renewed interest in the historic waterway along which Lexington was first developed, the Town Branch remains hidden from view in the center of Lexington and remains, for now, part of lost Lexington. But will this historic waterway resurface as part of Lexington's future? Only time will tell.

THE BLUEGRASS

Almost exactly in the centre of Kentucky lies this land of dream and sunshine.
Fayette County is the central pointe, and from its Court House the bluegrass
region stretches in a circle…The best part of it winds the Kentucky River, which
has cut its deep bed into the soft rocks there hundred feet below the surface, and
presents its picturesque cliffs in many featured crags as sentinels over the wimpling
waves below…It is near to Heaven and most blest of all the earth.
—J. Soule Smith, *Bluegrass Region of Kentucky.*

The undulating hills of the inner Bluegrass were some of our nation's first lands to cry forth "go west, young man." The early pioneers from North Carolina and Virginia traversed the Appalachian Mountains for new lands and opportunity in the fertile lands of Kaintuckee.

J. Soule Smith's words about a blessed Kentucky were penned in 1898. The words echoed those of famed local historian George W. Ranck whose *History of Lexington, Kentucky* remains one of the finest texts on early Lexington. Ranck wrote: "Fayette county, the center of the 'Blue Grass Region,' or 'Garden of Kentucky,' is situated in the middle of the state, and lies on the waters of the Elkhorn and Kentucky…It is fair table land, gently undulating; all the streams rise and flow from the center of the county and empty into their common receptacle, the Kentucky River."

The beautiful terrain and unmet potential that brought Daniel Boone to Kentucky also brought wave after wave of settlers. Over time, the settlements grew into towns and those towns grew into cities. As is the case

with our society, life moved onward. Faster and faster. Even in the earliest days of Kentucky's settlement, the beautiful landscape that brought settlers to central Kentucky was in need of "improvement" so that roadbeds could be more orderly and pasture could be more easily tilled.

The speed with which our population moved was only exceeded by the growth of the population itself. And that growth required and continues to require new lands to be settled. These issues have compounded upon one another as threats to the inner Bluegrass Region.

World Monuments Foundation Designation

In 2006, the World Monuments Foundation, or WMF, included the Inner Bluegrass Region on its watch list as one of the world's most endangered places. It was one of one hundred sites so designated as being both at risk and worthy of conservation. The WMF's designated area encompasses over 1.2 million acres stretching across portions of eleven central Kentucky counties.

The international attention garnered by the cultural landscape of the Inner Bluegrass Region was well deserved. In the nominating paperwork prepared by four nonprofit organizations committed to the preservation of Kentucky's cultural heritage, the following description of the region's significance was offered:

> *Widely known as the Horse Capital of the World, the Kentucky Bluegrass is one of North America's most unique cultural and agricultural landscapes. A place rich in natural resources and surviving building stock, the landscape contains many existing early 19th-century structures and illustrates more than 220 years of history and development based largely on an agrarian economy. Much of the prestige of the region is tied to its signature industry—breeding, raising, training, and racing prized horses—and related elements that create a strong sense of place: large and small farms, racing and training tracks, rolling hills and manicured paddocks, miles of rock and plank fencing, tree-lined turnpikes, horse barns with majestic spires, plantation-like mansions, and small service and outbuildings. Other influences exist alongside this equine landscape, supporting it and helping to define its distinctiveness. The region is the birthplace of burley tobacco production and bourbon distilling, each contributing to specialized building types and features important to American building history and central to*

The pictured burr oak is estimated to be nearly five hundred years old, is one of many ancient trees that still can be found in the Bluegrass region. Attempts are being made to save this oak, located along the Harrodsburg Road at Military Pike, from a new residential development. *Author's collection.*

the Bluegrass identity. While other areas around the world have thriving equine economies, the Kentucky Bluegrass bears no comparison because of its unique topography, building history, and spatial organization. This landscape is further enriched by its history related to tobacco and bourbon production, African American and immigrant settlement and craftsmanship, and early transportation networks. Together these elements tell a story of the interdependence of urban and rural economies, social hierarchies, adaptation of domestic spaces, transportation technologies, and the landscapes shaped by these forces.

Acknowledging the threats posed by the growing population in the region, poor planning by local governments and an even poorer collaborative effort on a regional basis prompted the inclusion on WMF's list.

Following the 1950 census, the population of the counties that now comprise the Lexington Metropolitan Statistical Area, or MSA, slightly

exceeded 175,000. During the 1970s, the population jumped over the population threshold of 300,000. As of the 2010 census, the MSA's population reached nearly 475,000.

Although the borders of the MSA and the eleven-county Inner Bluegrass Region are not identical, the regions are approximately the same. The growth experienced in the MSA is largely paralleled by the growth within the Inner Bluegrass Region.

This kind of population explosion has necessitated new places for people to live, work and shop. This growth, coupled with the poor planning that has allowed unrestricted growth to destroy acre after acre of the Commonwealth, are among the reasons prompting the World Monuments Foundation to designate our region on its list of endangered places.

The 1950s

In the early 1950s, Lexington's first true subdivision was developed off Leestown Road. The subdivision was named Meadowthorpe, after the large residence associated with the equine stock farm that once operated there. The area was also once the site of Lexington's first municipal airport, Halley's Field. It was here that Charles Lindbergh secretly arrived to visit his friend in 1928. Despite an attempt at secrecy for Lindbergh's visit, word spread of the famous aviator's arrival, and three thousand witnessed the challenging takeoff from the open field that was bound by both tree and telephone wires. Subdivision of the farm and the erection of houses at Meadowthorpe began in late 1949, with the subdivision's first homes being constructed from the limestone fences that once dotted the farm's landscape. At the time, living in Meadowthorpe was still considered "rural living."

Lexington's growth would soon became meteoric after International Business Machine Company (IBM) decided to build a 386,000-square-foot typewriter plant on Lexington's northeast side in 1956. The IBM plant would employ 1,800 individuals. Lexington, like other cities in post–World War II America, was destined to grow.

But Lexington's civic leaders recognized the importance of balancing the demands of new industry and a growing populace with the established equine and agricultural powers and the preservation of the landscape that those historic industries required. In 1958, Fayette County established a unique boundary that was the first of its kind.

The Urban Service Boundary created an urban city center where municipal services would be offered versus a rural area that would not be eligible for sewer or other municipal amenities. Lot sizes outside the urban service boundary could not be smaller than ten acres, and this was later restricted, in 1999, to lots smaller than forty acres. The result was a city that grew tightly in its geographic footprint while a significant portion of rural Fayette County retained its traditional character.

HARRODSBURG ROAD

Lexington is laid out as a wheel, with arterial roads functioning as spokes from the city's center. Most, if not all, of these spokes began as a private turnpike between Kentucky's cities. One southbound spoke is Harrodsburg Road.

Along Harrodsburg Road, the Springs Motel opened in 1948. A popular motor inn for travelers along Highway 68, the Springs Motel was expanded

The Springs Inn was demolished in 2009; its sign was all that remained in mid-2014. *Author's collection.*

in the 1950s. Throughout the latter half of the twentieth century, the Springs Motel (later known as the Springs Inn) was a popular place for lodging, dining and hosting of civic events and meetings. In 2009, the old motor inn was demolished, though the inn's large, old signage remained for a time in front of an empty field just waiting for new development.

Across the street from the Springs Motel, ground was broken in 1965 for Turfland Mall. This was Lexington's first indoor shopping mall when it opened in 1967. The shopping center remained popular for decades, though larger shopping complexes soon overshadowed it. The opening of these suburban, indoor shopping centers marked an exodus of both stores and shoppers from Lexington's downtown. Demographics and consumer preference continued to shift further away from Lexington's center, and these early developments near the city's core also shuttered. Turfland Mall, for example, closed in 2008.

HAMBURG PLACE AND BEAUMONT CENTRE

The trend further away from the city center marked the death of two great Lexington farms—Hamburg Place and Beaumont Farm. The two farms are located on opposite ends of Lexington, with the former being in northeast Lexington and the latter being in the city's southwest quadrant. In the place of each grew massive, mixed-use developments.

Beaumont Farm was once a four-thousand-acre gem along Harrodsburg Road—further from the city center than the location of the Springs Inn. Beaumont Farm had been owned by one of Keeneland's founders and its first president, Hal Price Headley. In the late 1960s, the farm was first split with the installation of New Circle Road. The inevitable occurred during the 1990s when developers began creating Beaumont Centre. The mixed-use development outside of New Circle Road is a city within a city, the Beaumont development includes hotels, restaurants, apartments, single-family homes, a library, shops and an outdoor amphitheater. Townhouses built in 2014 represented the final stage of development for Beaumont Centre.

Across town, the Hamburg Place farm also experienced major development. The origin of Hamburg Place began in 1898, when John Madden purchased 235 acres along the Winchester Pike. Madden, a successful thoroughbred trainer and owner, named his farm Hamburg after his horse of the same name, which had been sold and the proceeds

The entrance to Beaumont Centre development on Lexington's Harrodsburg Road. The development is named after the four-thousand-acre Beaumont Farm on which it was developed. *Author's collection.*

The horse cemetery at Hamburg Place is the burial place for many of John Madden's most successful stallions and mares. The cemetery was relocated from its original site, which is now a Wal-Mart parking lot. *Author's collection.*

from which were used to acquire the farm. Over the next several years, Madden would grow his Hamburg Place farm to some two thousand acres. Although John Madden died in 1929, his family continued his legacy and success.

Just as New Circle Road bifurcated Beaumont Farm, Interstate 75 dissected Hamburg Place when the road was built in the 1960s. The major road splitting the farm made unified operations somewhat more challenging. In 1996, the Madden family began developing their old family farm. Unlike Beaumont Farm, hundreds of acres of the old Hamburg Farm remain ripe for development. And over the next few generations, it is a near certainty that further development will come as hundreds of acres of Hamburg farmland remain on the other side of the interstate.

The names of Madden's horses are still represented on street signs: Old Rosebud, Sir Barton, Alysheba, Star Shoot and Pink Pigeon, to name a few. Honored street names and a relocated horse cemetery near a Wal-Mart parking lot might, in a generation, be all that remains of John Madden's equine operation. Lamenting the loss, a 2000 publication by the Sierra Club suggested that "the conversion of Hamburg Place, a historic farm outside of Lexington, is emblematic of the changes that poorly planned growth is bringing to Kentucky." The report went on to note that "where once there were 400 acres of trees and pasture there is now an Old Navy clothing franchise and lots of parking."

IS GROWTH GOOD? OR DOES IT DESTROY THE BLUEGRASS FOREVER?

Hamburg and Beaumont, regrettably, are just the tip of the iceberg. In most of the counties that surround Lexington, developers are able to devour farmland and destroy the unique identity of the region. In Scott County, Toyota began manufacturing vehicles at its Georgetown plant in the 1980s. Since, development in that county has boomed.

And in Madison and Jessamine Counties, a proposed connector road would link Nicholasville with Interstate 75. In its wake, historic landmarks and significant acreage would be lost, first by the road and later by the inevitable developments that would grow along the path over the ensuing decades. Other major developments in each of these counties only seem to beget further construction.

During the 1990s, competing bumper stickers challenged that either "Growth is Good" or that "Growth Destroys the Bluegrass Forever." As is the case with bumper stickers, neither took a fully accurate or a wholly informed position. The truth is that growth is necessary because our population is growing, and it is critical that we build places to work, live and play. Yet if we don't preserve our Bluegrass, then we are losing what makes the region so unique and desirable for that growth. A balance is critically necessary.

Balancing these seemingly countervailing proposals is challenging, but at least one local government—the Lexington Fayette Urban County Government—has taken a significant step toward preserving its irreplaceable farmland. Borrowing a page from various nonprofit organizations, the city began purchasing development rights (PDR) from private landowners, following the adoption of its PDR ordinance in 2000. Once acquired by the city, the land would retain its rural or agricultural character in perpetuity. As of 2014, Lexington had purchased development rights for 244 farms consisting of 28,169 acres. When the PDR ordinance was adopted by Lexington-Fayette, it was the first such ordinance in the country. It has been a tremendous success.

Still, a number of threats to the Bluegrass, both natural and man-made, continue to exist. These include development pressures, inadequate planning, lack of public awareness and understanding, obsolescence and changing farm economies and the growth of industrial development. The Bluegrass is a limited resource, and it is worth developing wisely. After all, the region is "near to Heaven and most blest of all the earth."

EPILOGUE

Like all cities, Lexington is a living organism. New development proposals threaten existing historic structures and picturesque vistas. A fire wreaks havoc on an old farmhouse or a new highway is planned. Each has the potential to contribute toward the demise of a chapter in our communal history. Anything might become part of *Lost Lexington*.

By the loss of any natural or historic resource in central Kentucky, the region loses part of its identity. Lexington is world-renowned for its location, history and charm. Without these characteristics, our communal identity is threatened and our city goes from being extraordinary to being ordinary. We honor *Lost Lexington* so that the mistakes of yesterday are not repeated with the landmarks of today.

A number of worthy organizations lead the charge for preserving central Kentucky's beautiful cultural and historic resources. I've listed a few below, though the list is certainly not exhaustive.

BLUEGRASS CONSERVANCY
www.bluegrassconservancy.org
(859) 255-4552

THE BLUE GRASS TRUST FOR HISTORIC PRESERVATION
www.bluegrasstrust.org
(859) 253-0362

THE FAYETTE ALLIANCE
www.fayettealliance.org
(859) 281-1202

KENTUCKY HERITAGE COUNCIL/STATE HISTORIC PRESERVATION OFFICE
heritage.ky.gov
(502) 564-7005

THE NATURE CONSERVANCY OF KENTUCKY
www.nature.org
(859) 259-9655

PRESERVATION KENTUCKY
www.preservationkentucky.org
(502) 871-4570

BIBLIOGRAPHY

Ambrose, William M. *Bluegrass Railways Railroads of Lexington, Fayette County, Kentucky*. Lexington: self-published, 2009.

Blue Grass Trust for Historic Preservation. "BGT's 'Eleven in Their Eleventh Hour' for 2014." *Preservation Matters*, (Winter 2014): 14–17.

Cincinnati Southern Railway. "Historical Timeline." *Cincinatti Southern Railway.* http://www.cincinnatisouthernrailway.org/about/full-timeline.php.

Croly, Jane Cunningham. "Another Old Kentucky Home, Chaumiere du Prarie," *The Home-maker: An Illustrated Monthly*, May 1890: 93–99.

De Valdes y Cocum, Mario. *Gibson*, "History of Kentucky." *The American Historical Society*. 1922. http://www.pbs.org/wgbh/pages/frontline/shows/secret/famous/dgibson.html.

Dreistadt, Ronnie. *Lost Bluegrass: History of a Vanishing Landscape*. Charleston, SC: The History Press, 2011.

Dunn, C. Frank. *Old Houses of Lexington*. Typescript. Lexington Public Library, n.d.

Eblen, Tom. *The Bluegrass and Beyond. Lexington Herald-Leader.* http://tomeblen.bloginky.com.

Foody, Terry. "Killer in the Bluegrass: The 1833 Cholera Epidemic in Lexington, Kentucky." www.terryfoody.net.

Gish, Pat B. "Fabulous Elmendorf Only a Ghost of a Vanished Era." *Lexington Herald-Leader*, January 20, 1954.

Griffin, David J. "Joyland Park," *Clay City Times* (Clay City, KY) June 28, 2007. http://www.hatfieldnewspapers.com/hatfieldnewspapers/archives/june.28.07/cct/cctedit.html.

Hale, Whitney. "Sesquicentennial Series: The Original White Hall." *University of Kentucky*. http://uknow.uky.edu/node/23668.

————. "Wildcat Marching Band: A Growing Tradition." *University of Kentucky*. http://uknow.uky.edu/content/wildcat-marching-band-growing-tradition.

Harland, Marion. *More Colonial Homesteads and Their Stories*. New York: Knickerbocker Press, 1899.

Harrison, Lowell H. *Kentucky's Road to Statehood*. Lexington: University Press of Kentucky, 1992.

Heavrin, Elizabeth G., preservation consultant. "South–West Main Street Commercial District; Woolworth's Block National Register of Historic Places Registration Form." 2008.

Hesseldenz, Peter. "Ernst Johnson Lecture at the Design Library 26th February." *Off The Shelf*. February 26, 2014. http://otsuklibraries. blogspot.com/2014/02/ernst-johnson-lecture-at-design-library.html.

House, Thomas M., and Lisa R. Carter. *Lafayette's Lexington*. Charleston, SC: Arcadia Publishing, 1998.

Kentucky Historic Resources Inventory. Kentucky Heritage Council, Frankfort.

Kerr, Bettie L. *Lexington: A Century in Photographs*. Lexington: Lexington-Fayette County Historic Commission, 1984.

Kleber, John E., ed. *The Kentucky Encyclopedia*. Lexington: University Press of Kentucky, 1992.

Klotter, James C., and Daniel Rowland, eds. *Bluegrass Renaissance The History and Culture of Central Kentucky, 1792–1852*. Lexington: University Press of Kentucky, 2012.

Knight, Thomas Arthur. *Country Estates of the Bluegrass*. Cleveland, OH: Britton Print Company, 1904.

Labach, William A. "Early Kentucky Ancestors." *William A. Labach*. http:// www.oocities.org/wlabach.

Lancaster, Clay. *Antebellum Architecture of Kentucky*. Lexington: University Press of Kentucky, 1991.

————. *Antebellum Houses of the Bluegrass*. Lexington: University Press of Kentucky, 1961.

————. *Vestiges of the Venerable City*. Lexington: Lexington-Fayette County Historic Commission, 1978.

Lexington City Planning and Zoning Commission. *Comprehensive Plan for Lexington and Its Environs*. Cincinnati: L. Segoe Consulting Engineer and City Planner, 1931.

Livingston, G. Herbert. "Chaumiere du Prairie." Unpublished paper. Asbury Theological Seminary, 1979.

Local History Index. *Lexington Public Library, Lexington.* http://local.lexpublib. org.

Meadowthorpe Neighborhood Association. *A History of Meadowthorpe Community.* Lexington, 1991. http://www.mnalex.org/history.htm.

Merkin, Zina. "The Disappearance of Town Branch." Unpublished paper. University of Kentucky, 2001.

Minutes of the University of Kentucky Board of Trustees. *University of Kentucky, Lexington.* http://kdl.kyvl.org.

National Register of Historic Places. Chaumiere des Praries, Nicholasville, Jessamine County, Kentucky. National Register #75000780.

———. F.W. Woolworth Building, Lexington, Fayette County, Kentucky. National Register #2000924.

———. Gratz Park, Lexington, Fayette County, Kentucky. National Register #73000796.

———. Southern Railway Passenger Depot, Lexington, Fayette County, Kentucky. National Register #87001364.

Oppel, Mary Cronan. "Paradise Lost: The Story of Chaumiere des Praries." *The Filson Club History Quarterly,* 56, (1982): 201–10.

Peet, Henry J., ed. *Chaumiere Papers.* Chicago: 1883.

Ramage, James A. *Rebel Raider: The Life of General John Hunt Morgan.* Lexington: University Press of Kentucky, 1986.

Ranck, George W. *History of Lexington Kentucky.* Cincinnati: Robert Clarke and Company, 1872.

Sasaki and Ross Tarrant Architects. "University of Kentucky Concept Alternatives." February 5, 2013.

Sierra Club. "Fall 2000 Sprawl Report." *Sierra Club.* http://www.sierraclub. org/sprawl/50statesurvey/Kentucky.asp.

Slayman, Andrew. "A Race Against Time for Kentucky's Bluegrass Country." *ICON,* Spring 2007:16–21.

Smith, J. Soule. *Art Work of the Blue Grass Region of Kentucky* (Art Photogravure Company, 1898). *Kentucky Digital Library.* http://kdl.kyvl.org/catalog/ xt7vdn3zt134_1_77/guide.

Smith, John David, and William Cooper Jr., eds. *A Union Woman in Civil War Kentucky: The Diary of Frances Peter.* Lexington: University Press of Kentucky, 2000.

———. *Window on the War: Frances Dallam Peter's Lexington Civil War Diary.* Reprint, 1976. Lexington: The Blue Grass Trust, 1992.

University of Kentucky. "Campus Guide." *University of Kentucky*. http://www.uky.edu/CampusGuide/buildings.html.

University of Kentucky Athletics, "Archives." *University of Kentucky*. http://www.ukathletics.com/sports/m-footbl/archive/kty-m-footbl-archive.html.

University of Kentucky College of Design, et al. "Nomination to the World Monuments Fund World Monuments Watch." (Lexington, 2004).

University of Kentucky College of Engineering. "The Kentucky Engineer." *The Kentucky Engineer*, December 1940: 3–21.

University of Kentucky Yearbook Collection. *Kentucky Digital Library*. http://kdl.kyvl.org.

Wall, Maryjean. *How Kentucky Became Southern*. Lexington: University Press of Kentucky, 2010.

WikiLex. LexHistory fka Lexington History Museum, Lexington. http://www.lexhistory.org/wikilex.

Wright, John D., Jr. *Lexington: Heart of the Bluegrass*. Lexington: Lexington-Fayette County Historic Commission, 1982.

Youker, Darrin. "Roller coaster legacy of Reading man survives." *Pittsburgh Post Gazette*, August 9, 2009.

Young, Bennett H. *History of Jessamine County, Kentucky*. Louisville: Courier-Journal Job Printing Company, 1898.

INDEX

ABOUT THE AUTHOR

Peter Brackney is an attorney and local historian who adopted Kentucky as his home early in life. His award-winning blog and website, kaintuckeean.com, is a repository of Kentucky's unique and wonderful history. Brackney serves on the boards of the Blue Grass Trust for Historic Preservation and the Lexington History Museum. He lives near Lexington with his wife and children.